AMERICAN COCKROACH

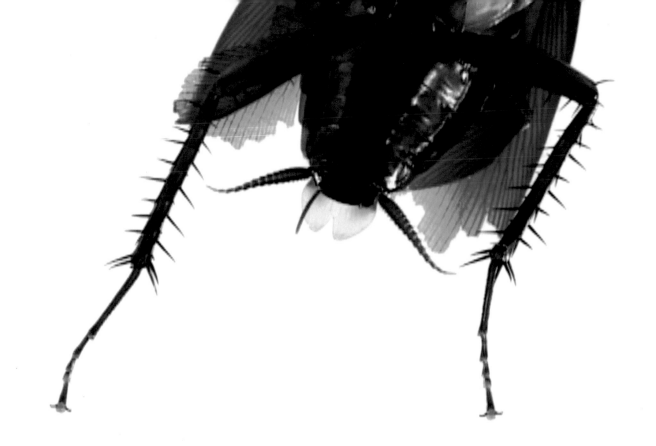

CATHERINE CHALMERS

AMERICAN
COCKROACH

APERTURE

American cockroach
(*Periplaneta americana*)
ALSO KNOWN AS: water bug,
palmetto bug. *n.* cold-blooded
invertebrate; one of the oldest
and most successful animals
on earth; largest of common
peridomestic cockroaches.
Average size: two inches
in length; Average life
span: 100–500 days

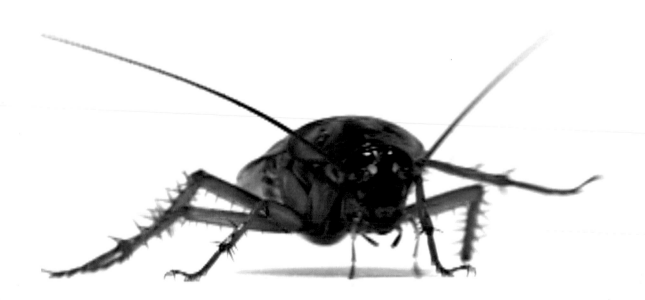

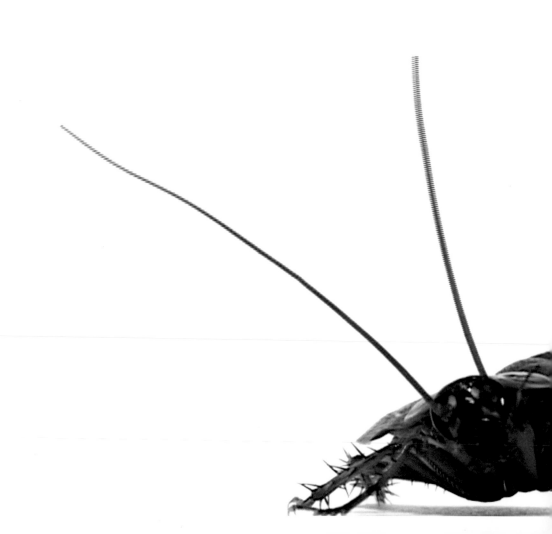

resident: *adj.*
living in a place for
some length of time;
n. one who resides
in a place

Almost everything we know or believe about cockroaches is exaggerated.

It is true that their speed and unpredictable movements in the dark are enough to cause anxiety in most homes, and that they can multiply alarmingly if left undisturbed, but not all the news is bad. The scientific name for the most common cockroach to become domiciliary (an unpleasant thought), is *Periplaneta americana*, suggesting that this pest (which actually originated in Africa) has conquered the world. Far from it.

There are, in fact, nearly 4000 known species of cockroach on the planet and no more than a dozen of these come into homes anywhere at anytime. And when they do, they are usually in search of warmth and, if we are sloppy about it, food. The rest are still out there, where they have been for 400 million years, going about their lawful and useful business scavenging in tropical forests, temperate wetlands, limestone caves, and the nests of ants and wasps. So, in a very real sense, if a few cockroaches have become intruders, loathsome to us, we have only ourselves to blame. Cockroaches are pests of poor hygiene.

That uncomfortable insight, however, doesn't prevent large numbers of us from feeling that these flat, twitchy, squishy, spine-legged, and durable outsiders are abhorrent. They cause people real mental distress, but this is a psychological, not a logical, problem. Studies have demonstrated that cockroaches are not vectors of deadly

diseases such as typhus and plague that are spread by the likes of lice and fleas. Cockroaches are fastidious insects and if they accidentally carry any pathogens at all, they pick these up in unsavory places of our construction and dereliction.

All of which seems to suggest that "the most obnoxious insect known to man" is the victim of unusual and largely unjustified prejudice and persecution.

Our relationship with cockroaches is a long one, going all the way back to our first cave dwellings, perhaps 100,000 years ago. But for cockroaches, that amounts to nothing more than a brief encounter in an evolutionary process 4000 times longer. And they will probably carry on, doing what they do best, long after we have all gone.

When faced with any such social quandary, humans instinctively distance themselves from its source. We rush to put as much space as possible between us and whatever it is that has made us feel so uncomfortable. And, more often that not, we stack the deck in our favor by dehumanizing our adversaries. Once that ploy has been put into play, anything goes. It is us against them, and in such conflicts, truth and reason are the first casualties.

"Cockroach!" The word itself has become an insult in every language as people heap easy abuse on anything alien. In East Germany, cockroaches were called *Russe,* "The Russians"; while in West Germany, they were identified instead as *Franzose,*

It is us against them,
and in such conflicts, truth and
reason are the first casualties.

"The French." Everywhere, antipathy rules and remedies abound for their destruction. These range from the practical Japanese naval solution of offering one day's shore leave for any crewman who captures 300 of the insects onboard; to the more clerical Mexican recipe which advises catching three *cucaracha* in a bottle and turning these loose at a crossroads one by one, to the accompaniment of a musical setting of the Nicene creed.

There are very few communities anywhere who welcome cockroaches, though there is heartening news of one early traveler in British Columbia in the nineteenth century who was served cockroaches in three different styles: alive in strawberries, á la carte with fried fish, and baked in biscuits. He must have been a biologist. We figure prominently amongst the few who enjoy cockroaches, if not in our food, then as vivid examples of evolutionary success, and as the performers of one of the most moving and graceful courtship displays in the animal kingdom.

Cockroaches are largely nocturnal and communicate mainly by smell and touch. Females differ little from males in appearance, but produce a very characteristic musky-nutmeg sort of odor that pervades their environment and has strong pheromonal effects on any passing male. When a pair meet, their first contact is by a timorous touch of the tips of their long whip-like antennae in modest introduction. This is followed by equally diffident mutual body-stroking which grows slowly into a

"Cockroach!" The word itself has become an insult in every language as people heap easy abuse on anything alien.

sort of playful sparring. The male hisses softly to her until such endearments are sufficient to start her trembling and rocking. Then the dance begins.

He raises his wings and offers the tip of his abdomen to her, provocatively, and then retracts it, teasing her again and again as they turn in a stately pavane. And this goes on until she cannot stand it any longer and lunges at a gland under his wing which produces the reward of a drop of nuptial secretion. That excites her even more and the foreplay accelerates into a swirl of wings and legs that ends with her straddling him from above in a long, leisurely copulation that can go on for an hour or more.

It is hard, after witnessing such a performance, not to see cockroaches in a different light, and impossible to stomp on one with impunity. Knowledge narrows the psychic space between us. But the fact remains that every such tender mating leads to a succession of instars and nymphal stages that can produce as many as 1000 new cockroaches. And however fascinating these might be, the problem is that some of them are bound to infringe on the private, personal space of our homes, where even birds and butterflies are unwelcome if uninvited.

Trespassers *will* be persecuted.

<div align="right">

—LYALL WATSON

</div>

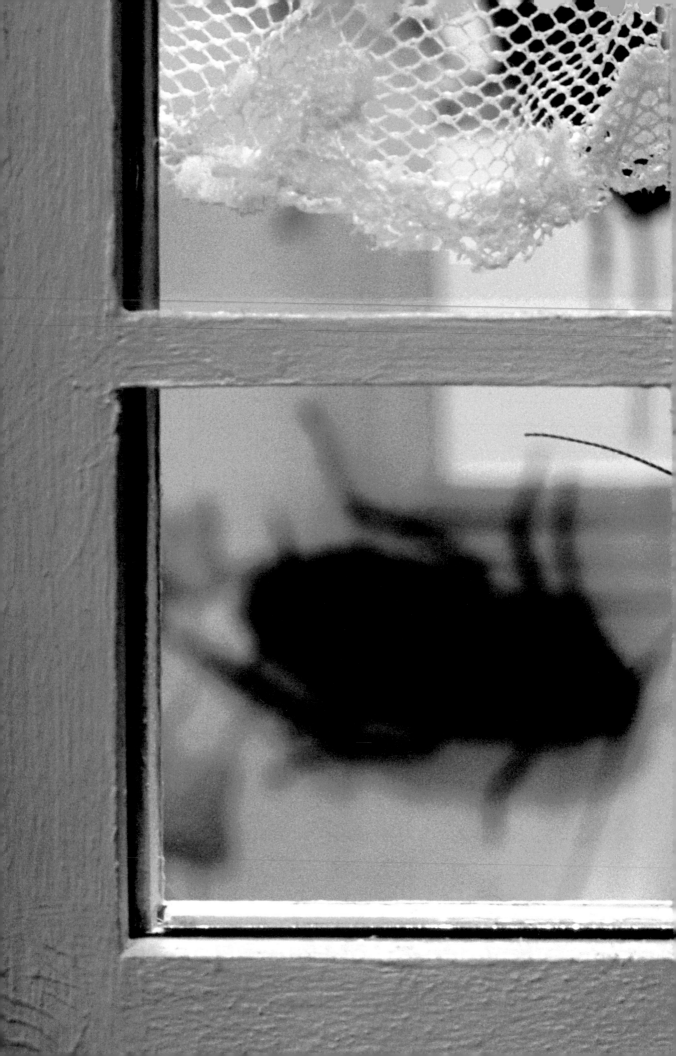

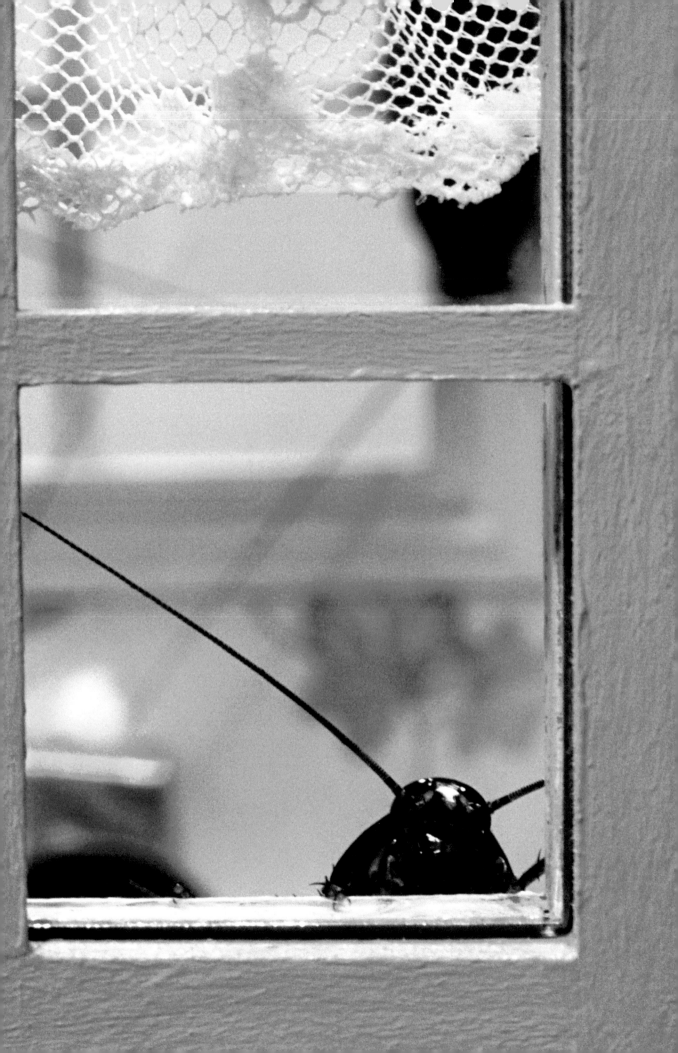

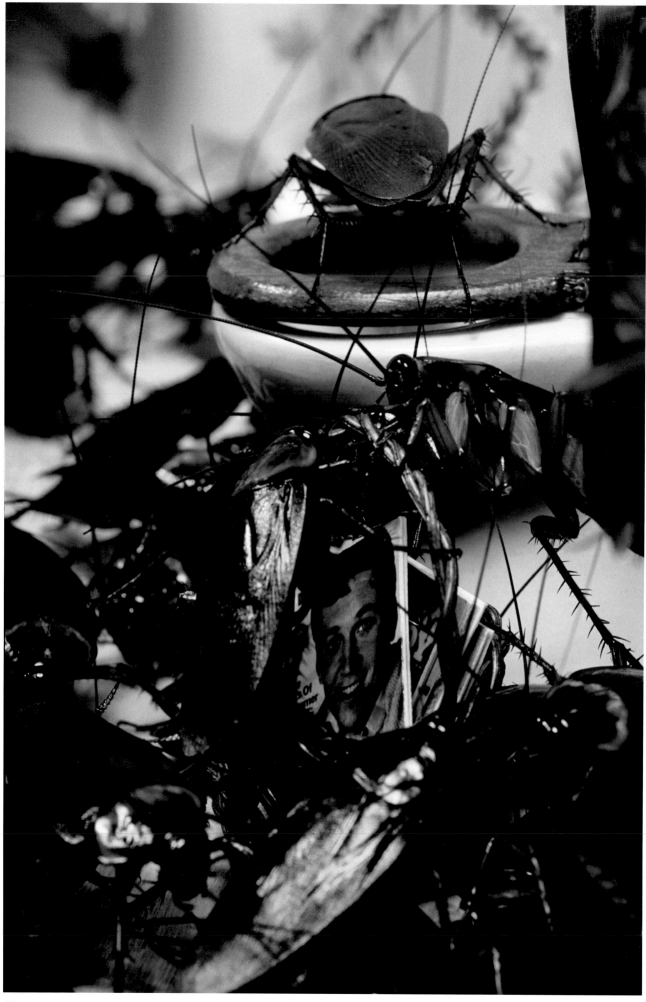

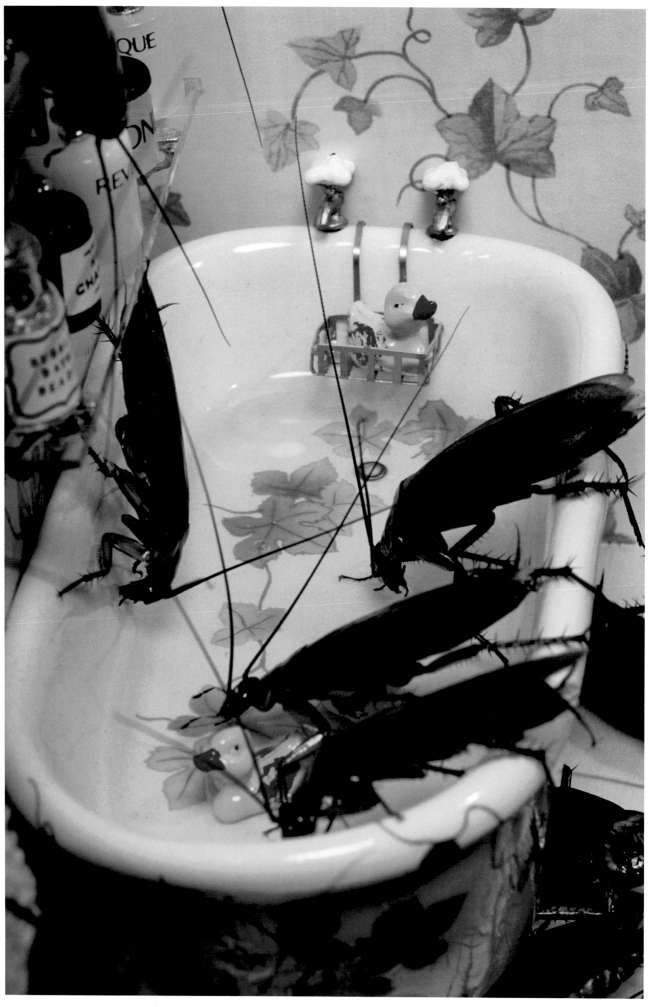

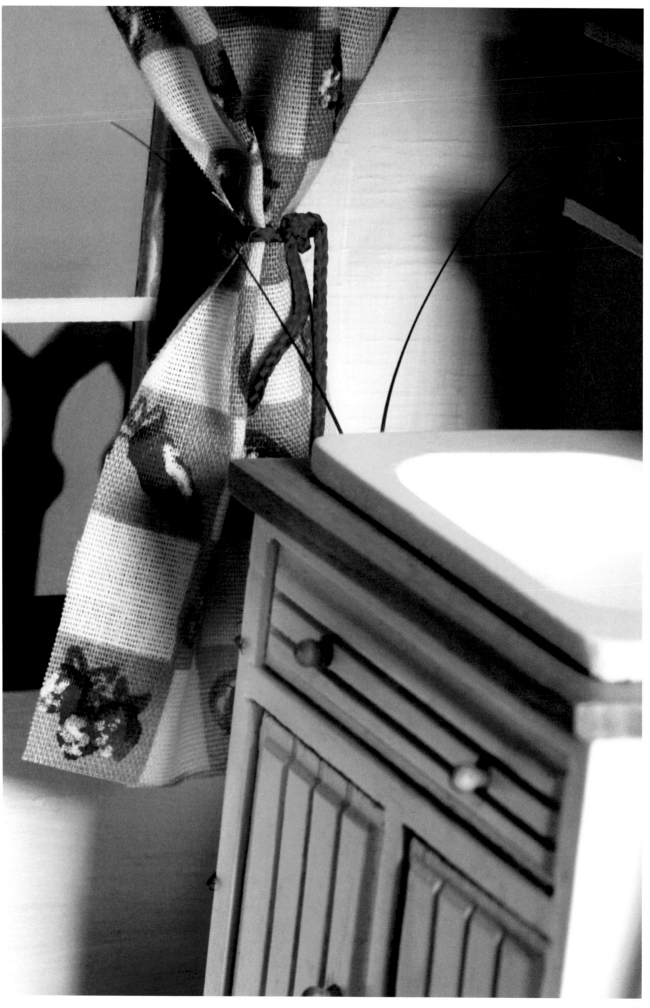

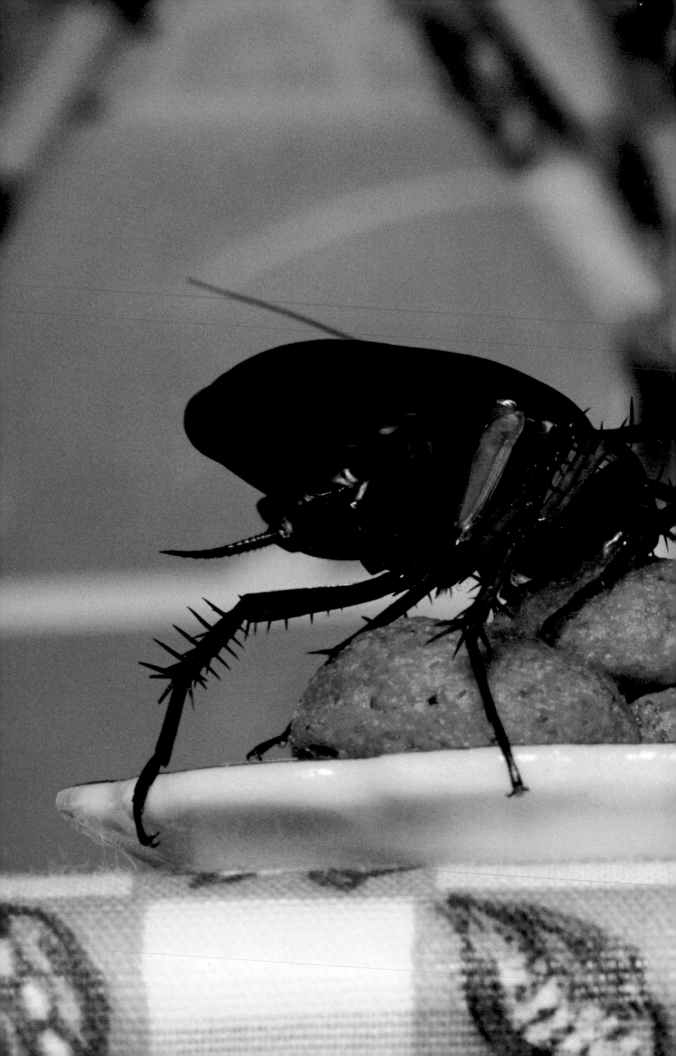

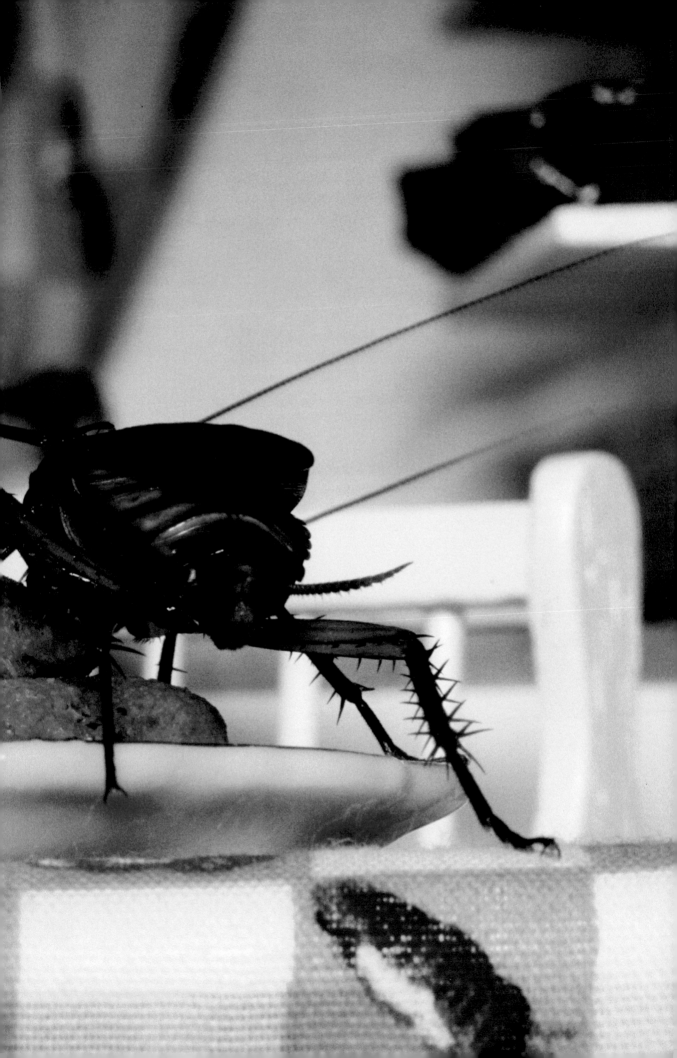

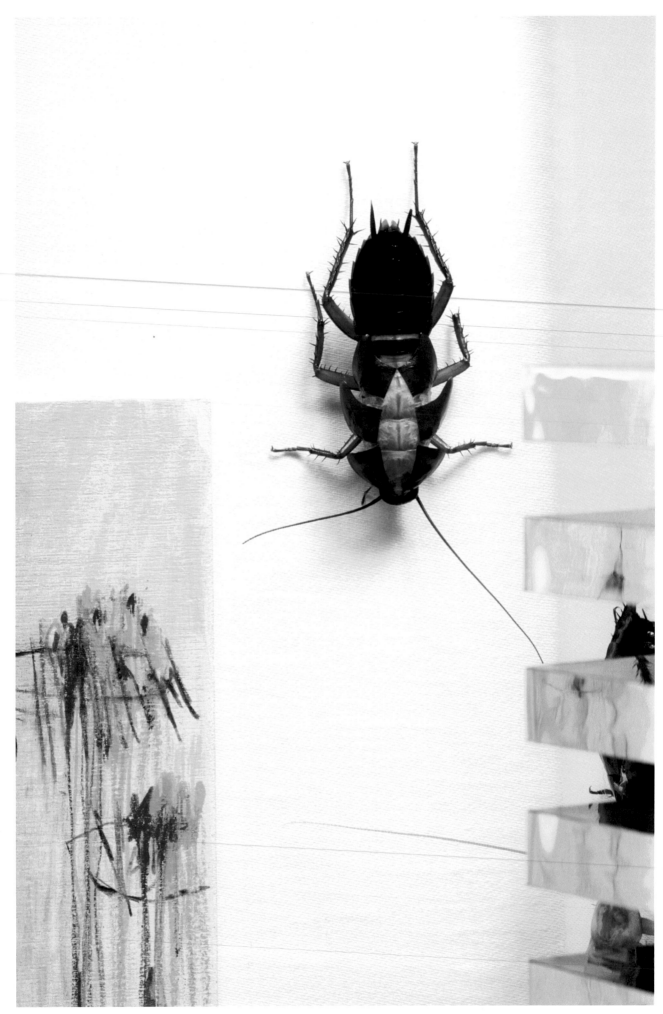

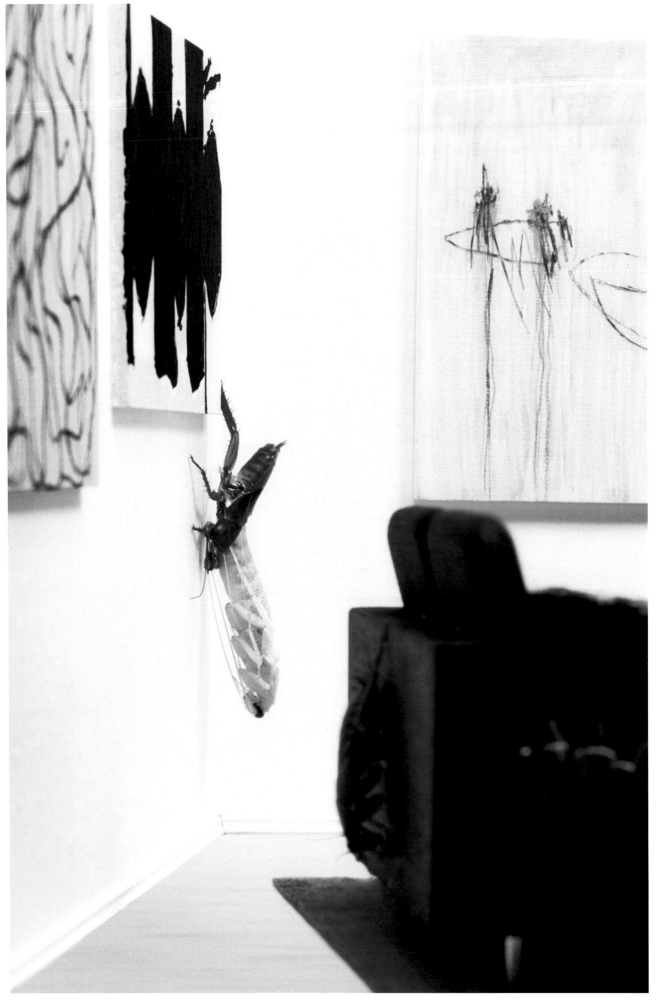

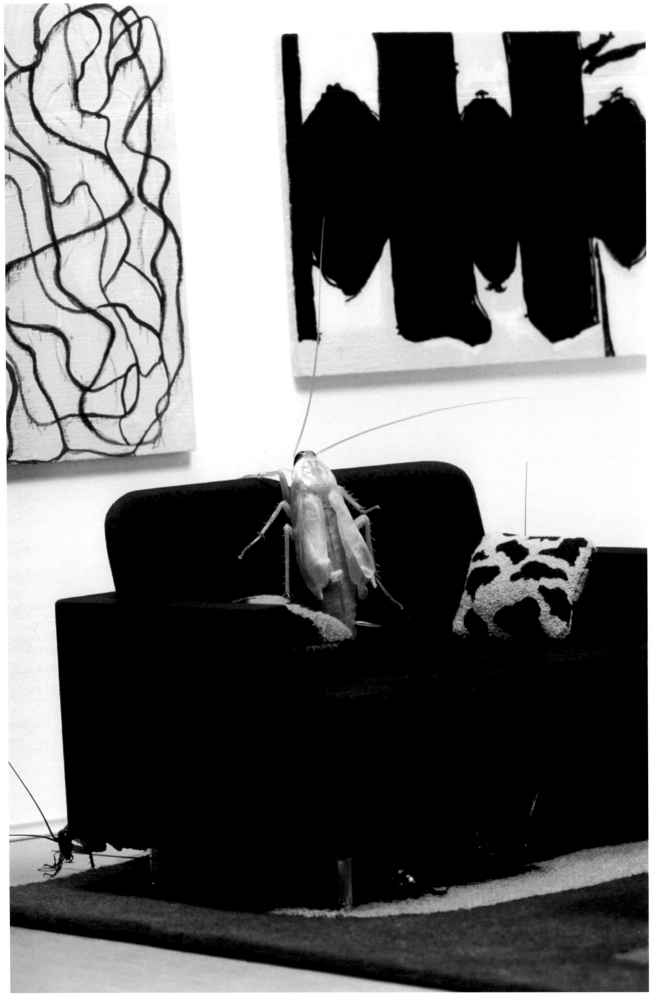

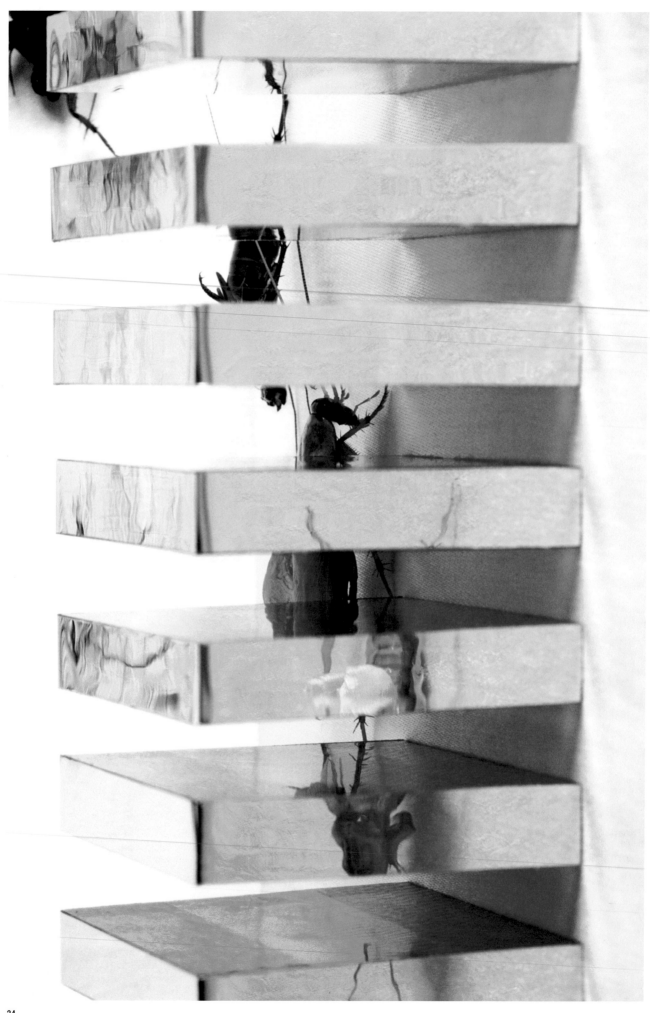

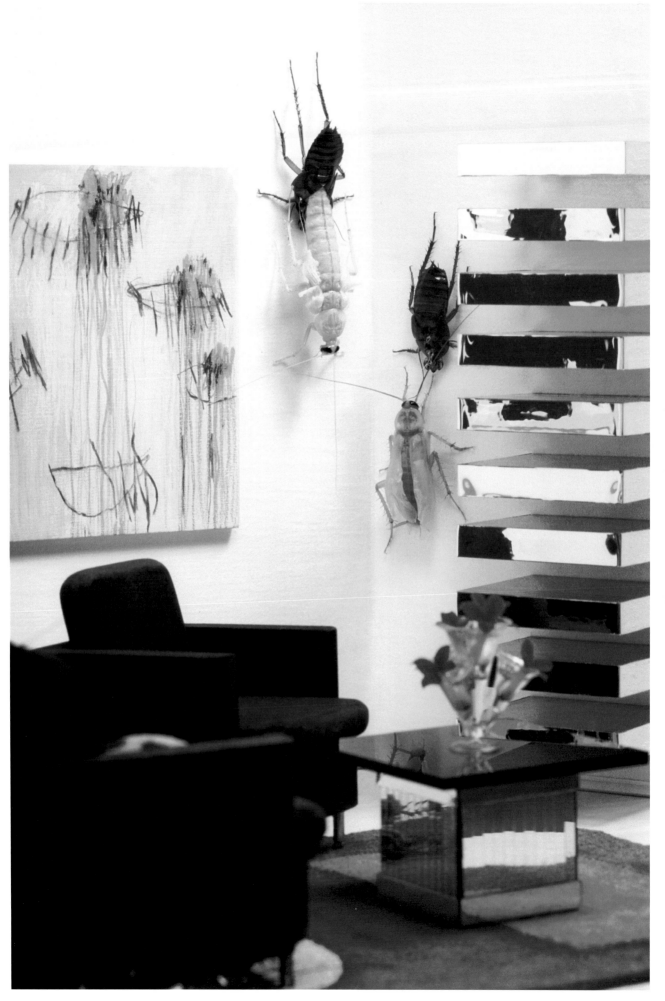

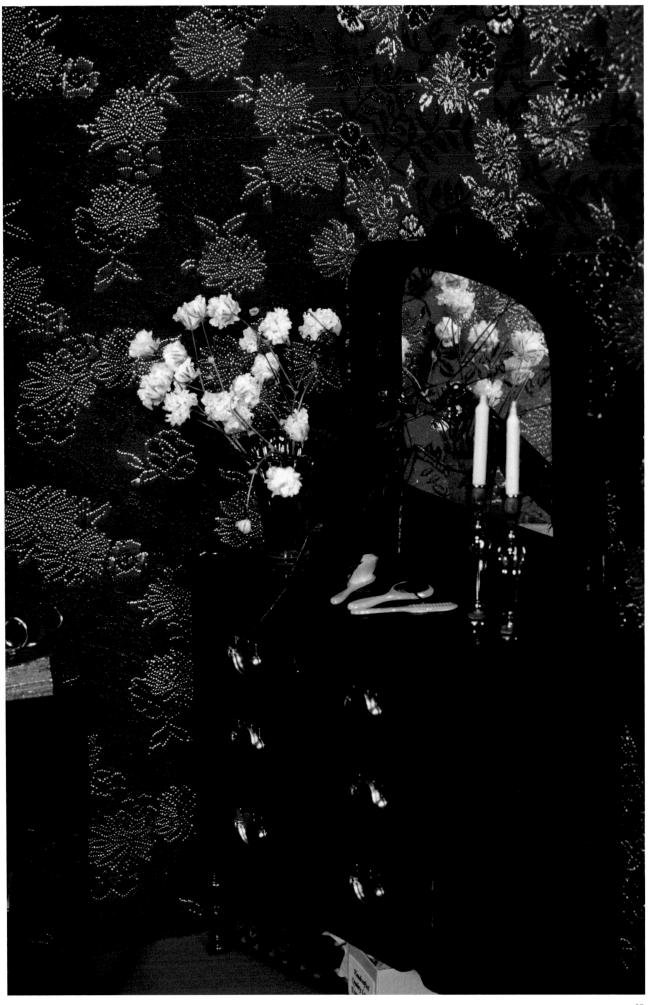

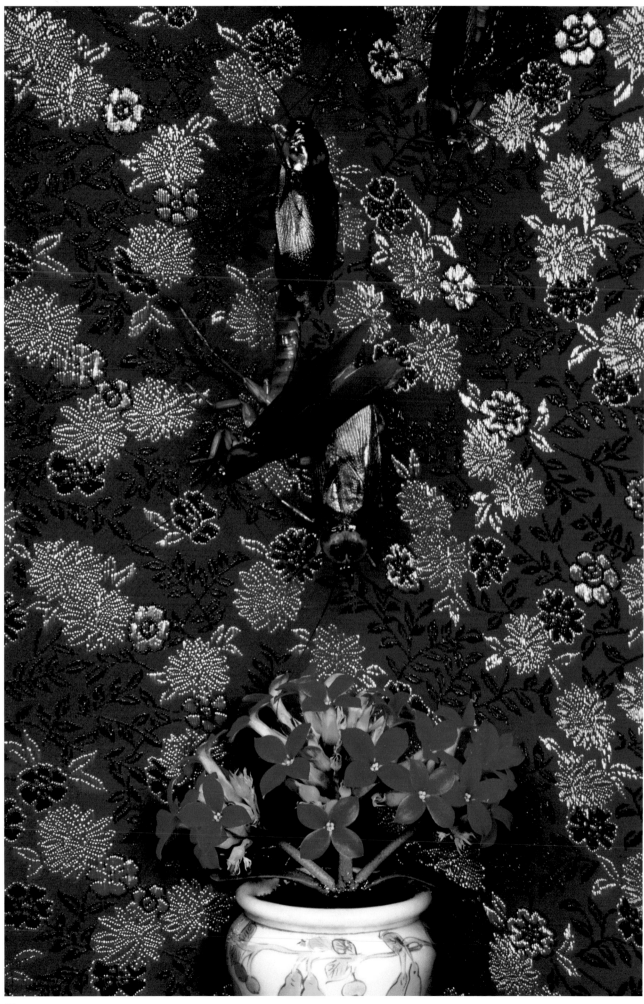

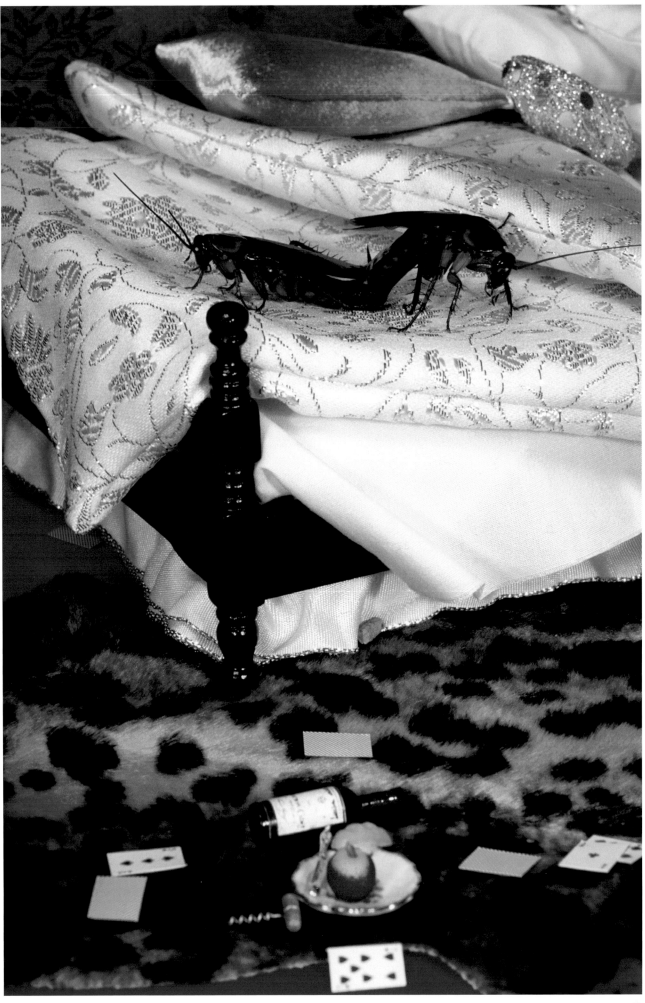

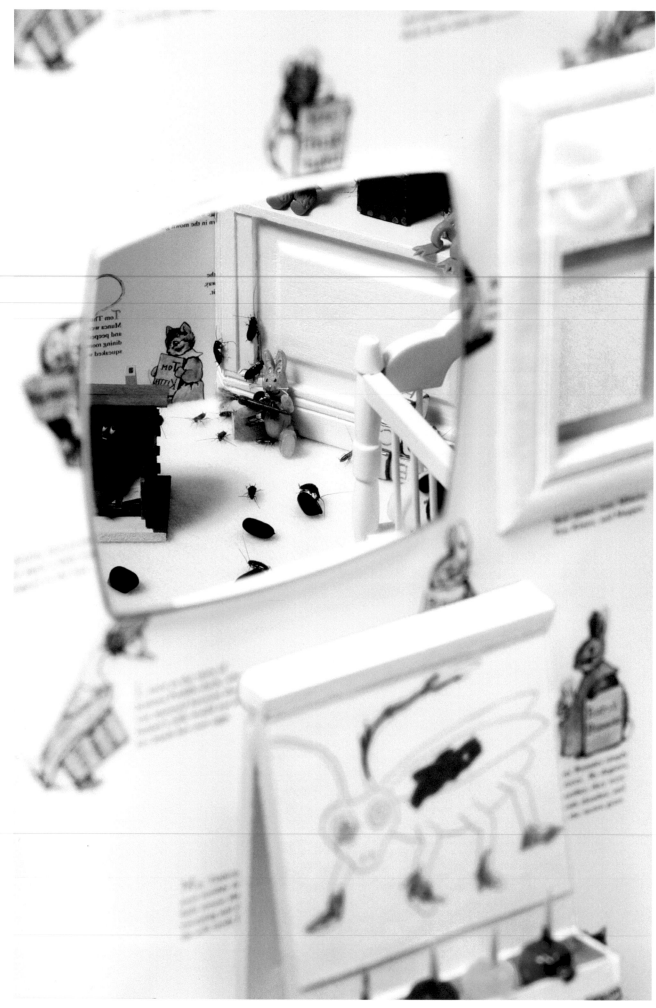

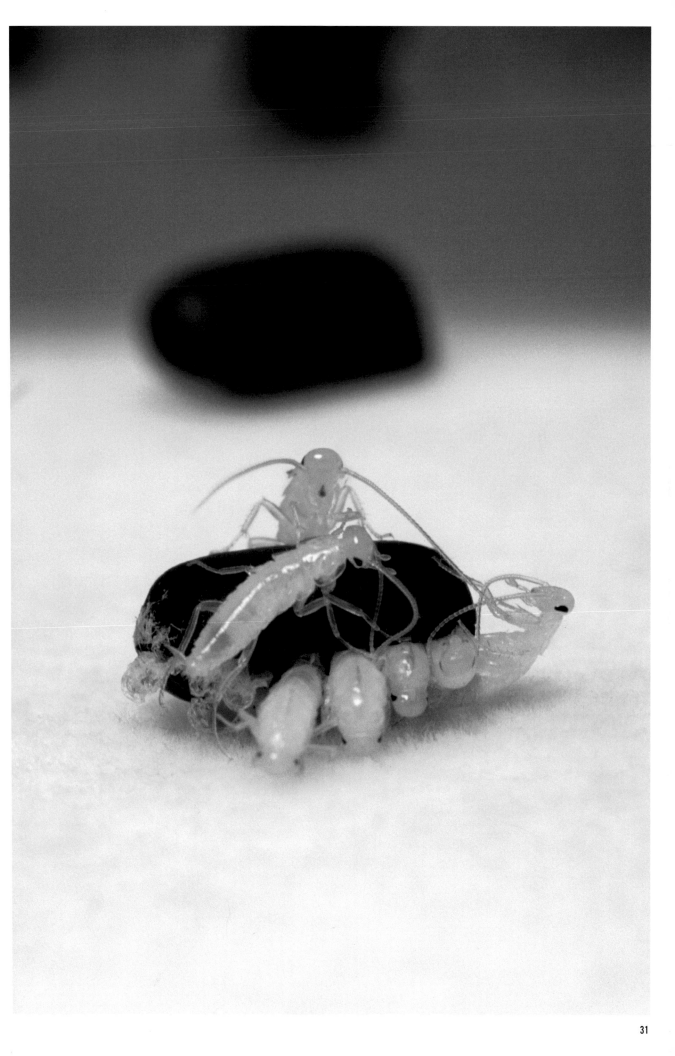

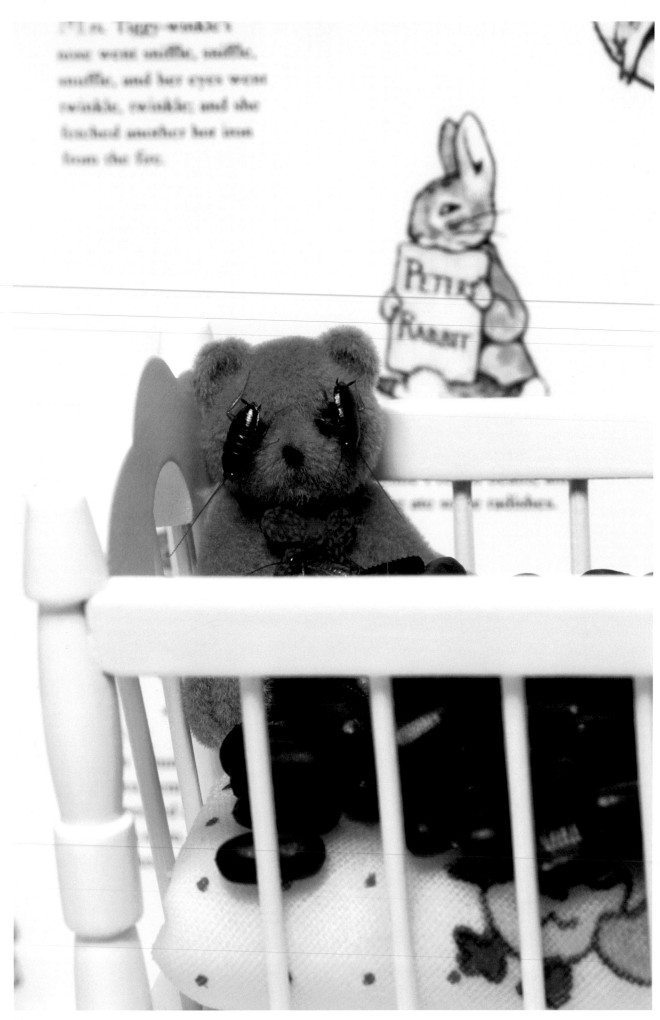

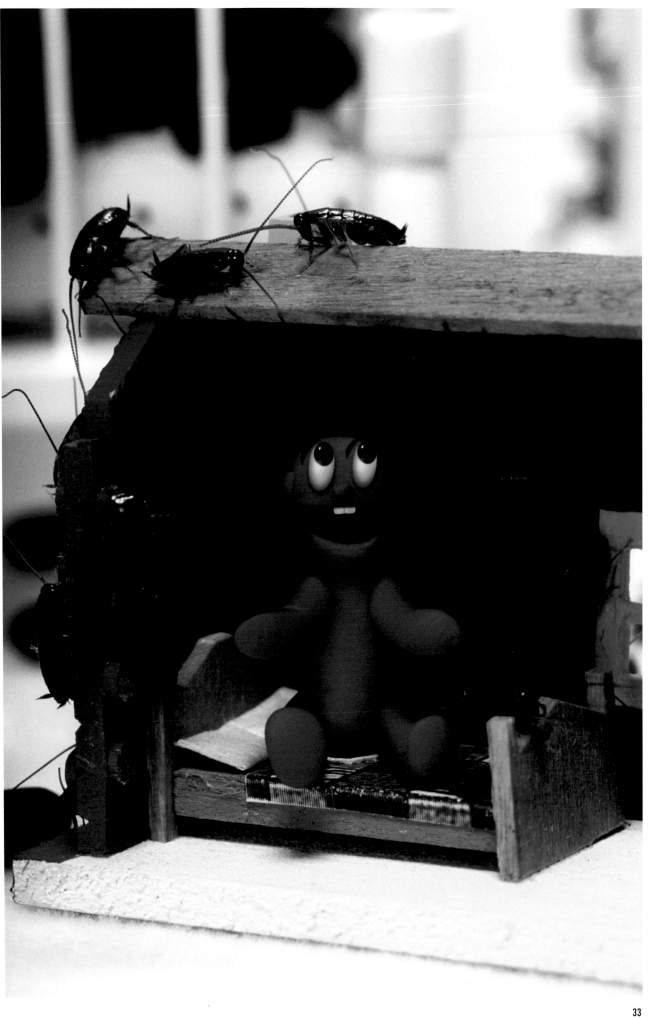

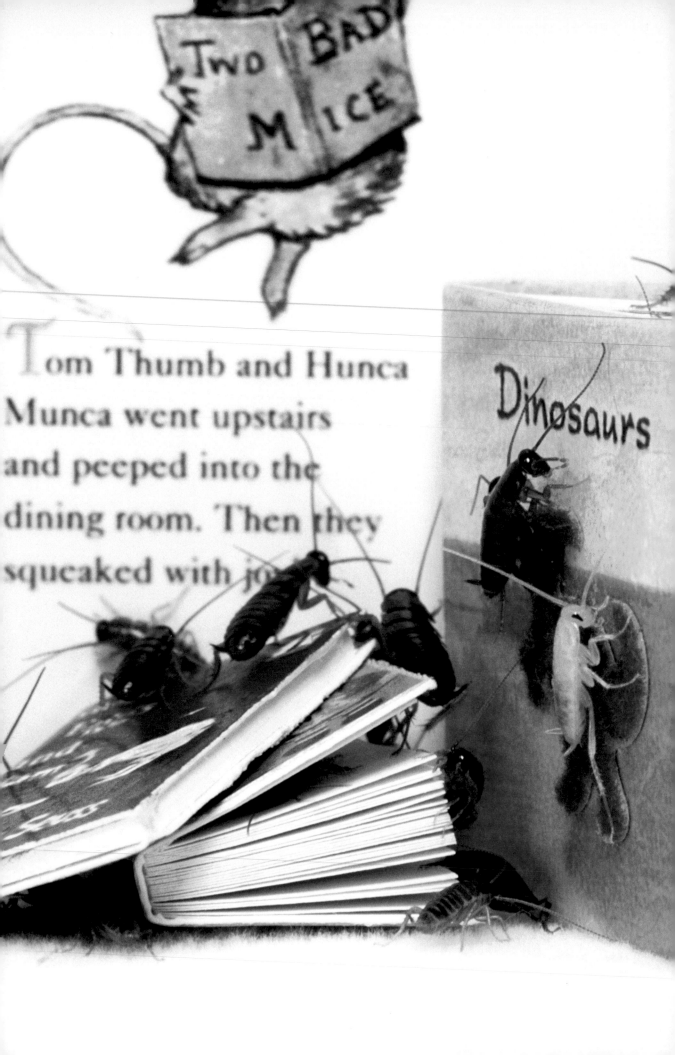

TWO BAD MICE

Tom Thumb and Hunca Munca went upstairs and peeped into the dining room. Then they squeaked with jo

Dinosaurs

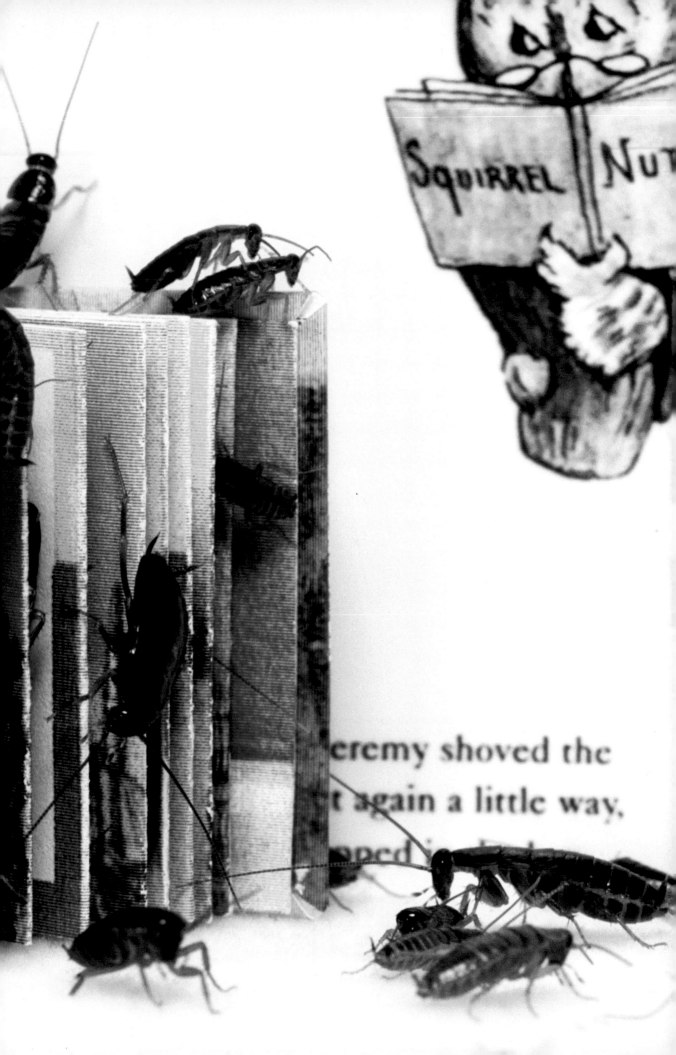

SQUIRREL NUT

eremy shoved the
t again a little way,
oped in...

impostor: *n.*
one that assumes
false identity or title
for the purpose
of deception

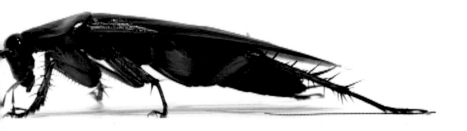

IMPOSTORS

What do we want from cockroaches (apart, that is, from our unrealistic desire for them not to be there)? "My interaction with animals is part of what I want," Catherine Chalmers has said. "I want to see if it's possible, even for a moment, to get out of our humanness and to imagine life as a cockroach, to explore the world with long feelers."

Of *American Cockroach's* three photographic series, "Impostors" is in certain respects the darkest and most difficult. It's the series in which the artist seems most directly to address her own fear of these creatures. The imagery is hallucinatory, visceral. It's an imagery of unfathomable dread, of terror tinged with beauty, and not—as it might first appear—of a beauty that's merely tinged with terror. The flora and fauna of this strange blue world recall the complaint of a character in a Tom Robbins novel about his hateful experience of the "sticky, buggy, rainy" environment of the Amazon jungle: it's just "too damn vivid."

The "Impostors" series shares neither the sci-fi exaggerations of scale seen in "Residents," nor the revenge-fantasy imagery of "Executions." Its subversions are more subtle. It is also the series least concerned with anthropomorphism, and least likely to provoke it in the viewer. Not that anthropomorphism need always be seen as demeaning to the animal: the roach in the electric chair (from "Executions"), for example, is regal, magnificent, insolent. But the aloesaurus, the bumble beetle, the peacockroach, and the orchid bug, imaginary though these impostors may be, are unquestionably and indestructibly insectile. The fear they induce is not that of

It is a world, an ecosystem, where nothing is familiar, where the scale of things is hard to figure, and where plant and insect—aloe and aloesaurus— are in cahoots, in alliance.

suffering Gregor Samsa's fate, of metamorphosing into such a creature, but rather of being somehow preyed upon, incorporated. (In her recent book on the cockroach, Marion Copeland notes that the New York Police Department "has a full-time entomologist to determine whether wounds on the city's murder victims were caused by human violence or hungry cockroaches.")

"What," Chalmers asks, "are the aesthetics of our sympathies?" In setting out to explore this largely neglected question, she imagines a world shorn of human sympathy, certainty, and morality (despite her determination, in the staging of these dramas, "not to hurt anything"). It is a world, an ecosystem, where nothing is familiar, where the scale of things is hard to figure, and where plant and insect—aloe and aloesaurus—are in cahoots, in alliance, bound up in the same deception, whose purpose and whose ends remain unclear. As John Berger once observed of another such all-embracing worldview: "If, before a cartoon sequence by Disney, one read and believed the caption, There is nothing else, the film would strike us as horrifically as a painting by Bacon." This is why even the apparently prettier impostors—that cluster of elongated lady bugs, for example—have their own relation to terror.

The preposterous fuzzy-backed thing in *Sweet Veronica (portrait)* is perceived as doing precisely what humans cannot bear animals to do: it is waiting, looking— looking at you. The gaze is inescapable; its effrontary intolerable. Here, insect and artist are at one: photographing these scenarios with a macro lens from a

distance of only inches, Chalmers offers a "roach's-eye view" that momentarily eschews human identity and control. "I like getting into where I can't see myself," she has revealingly remarked.

In relation to her earlier "Food Chain" project, the artist expressed an interest in "removing that distance" between image-maker and animal that so often characterizes nature photography: "I wanted to interrupt the relative comfort of 'they're there and we're here.'" In the unnatural world of "Impostors," distance—like scale—is all but impossible to judge. This art does, however, seem to acknowledge shifts in the natural order of things, such as the fact that the American cockroach, *Periplaneta americana*, is no longer to be found in the wild.

Over the past decade Chalmers has been investigating how she might address human expectations of (and prejudices about) animals and nature while operating "in the art category, as opposed to the nature category." The "Impostors" series pursues this project: it cranks up the imagery of nature to the point that it's an assault on the eyes, burned into the visual memory, too damn vivid, a vision pushed to the point where we have no idea what we're seeing, nor of what it is that's looking back at us.

The artist has spoken of her fascination with those points "where the natural world and the cultural world cross," but there are crossings of speed and slowness at work here too, marking out a precarious equilibrium between artist and animal. As the cockroaches are

The preposterous fuzzy-backed thing in *Sweet Veronica (portrait)* is perceived as doing precisely what humans cannot bear animals to do: it is waiting, looking—looking at you.

placed on the flowers and foliage of the studio set, and begin to stir from their artificially chilled sleep, Chalmers has to judge with care the pace of her own movements. Artist and camera moving slowly and deliberately, mindful that any too-sudden movement may cause the creatures to panic, she readies herself for the moment "when they are acting like roaches. That's what you want." A quarter of a century ago, Deleuze and Guattari mapped out their influential philosophical concept of becoming-animal in strikingly similar terms. Focusing on the adoption of an animal pace rather than an animal form, they envisaged the process of becoming-animal as an attention to the relations of "speed and slowness that are closest to what one is becoming. This is the sense in which becoming is the process of desire."

Chalmers' vision is a productive one precisely in its unsettling of human preconceptions of the animal, nudging them along, keeping them moving, like the cockroaches themselves. "Their movement is beautiful. I love that part of it," she has said. And if it is the roaches' fleetness rather than their form that the large-scale C-prints of the "Imposters" series so effectively disguise, the images nevertheless carry echoes of Deleuze and Guattari's words when they wrote of "the violence of these animal sequences, which uproot one from humanity, if only for an instant." The instants fixed with such care by Chalmers might also be those in which viewers, like the artist herself, can unexpectedly glimpse their own desire "to get out of our humanness."

—STEVE BAKER

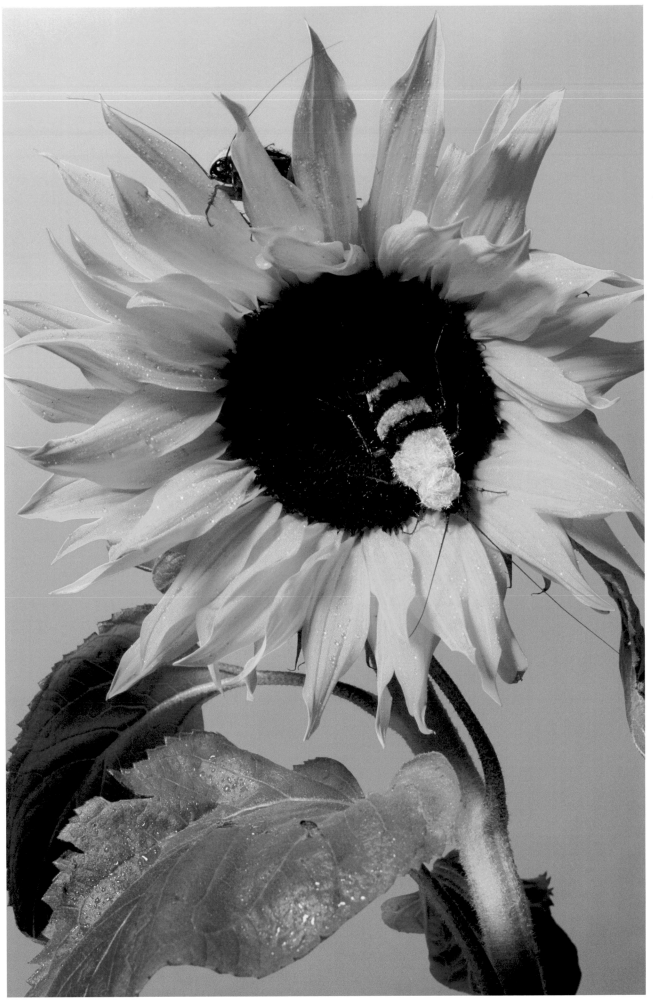

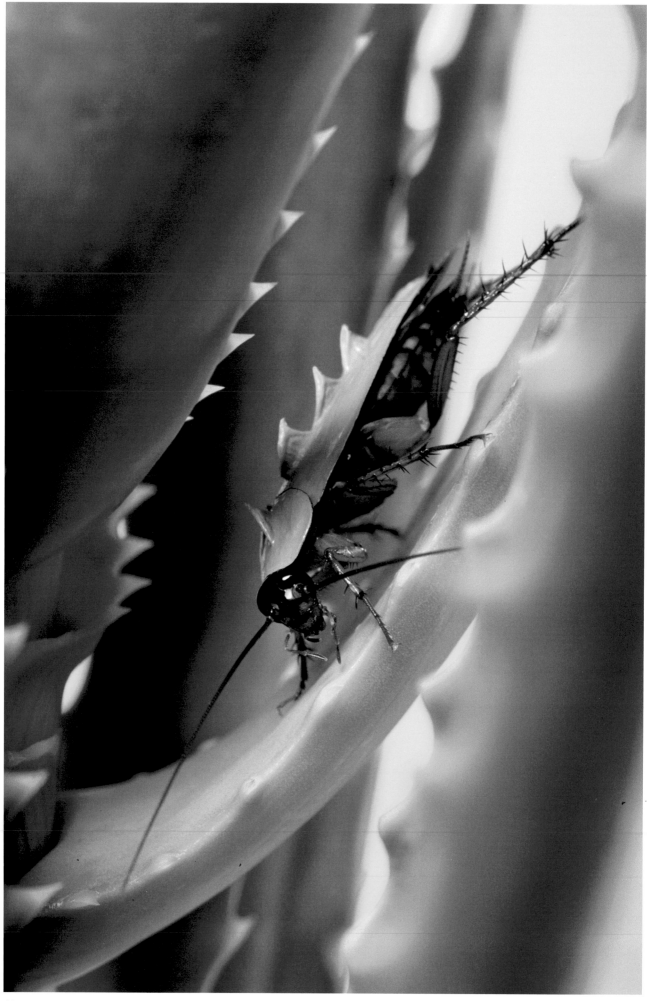

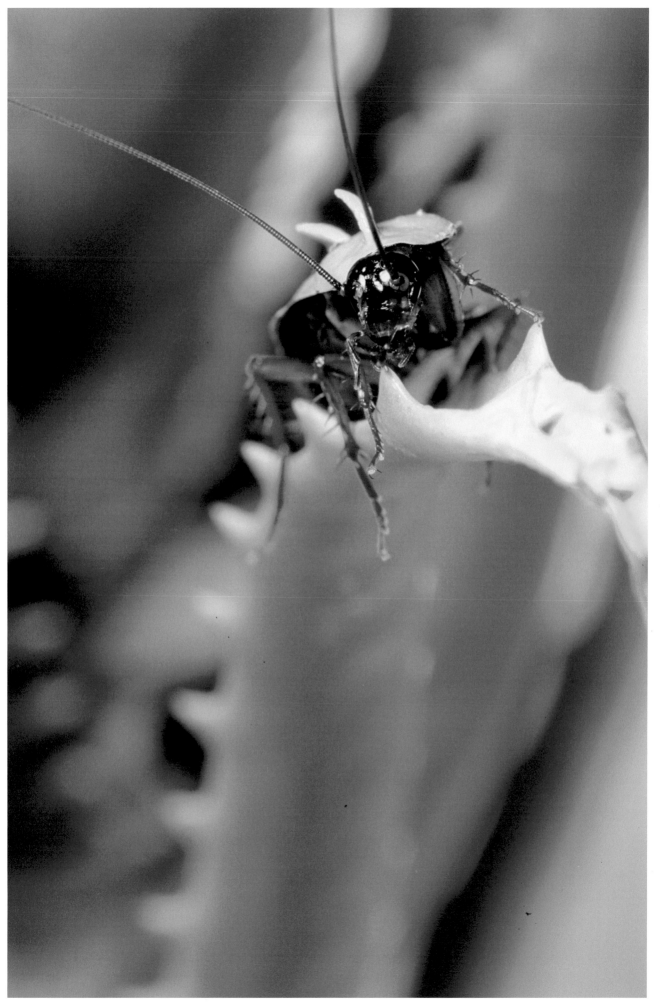

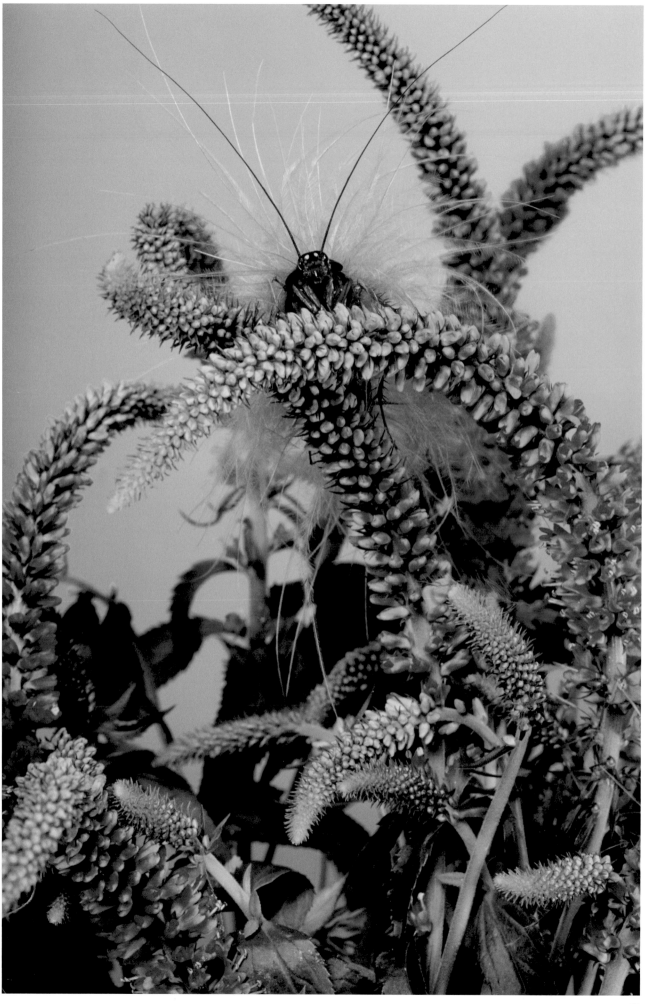

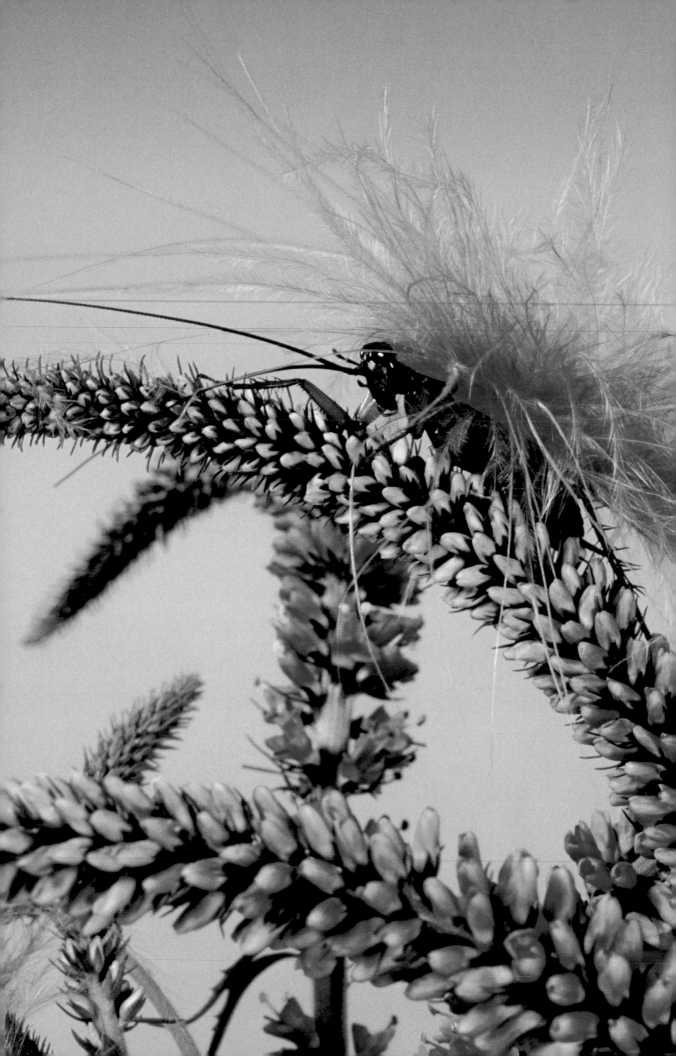

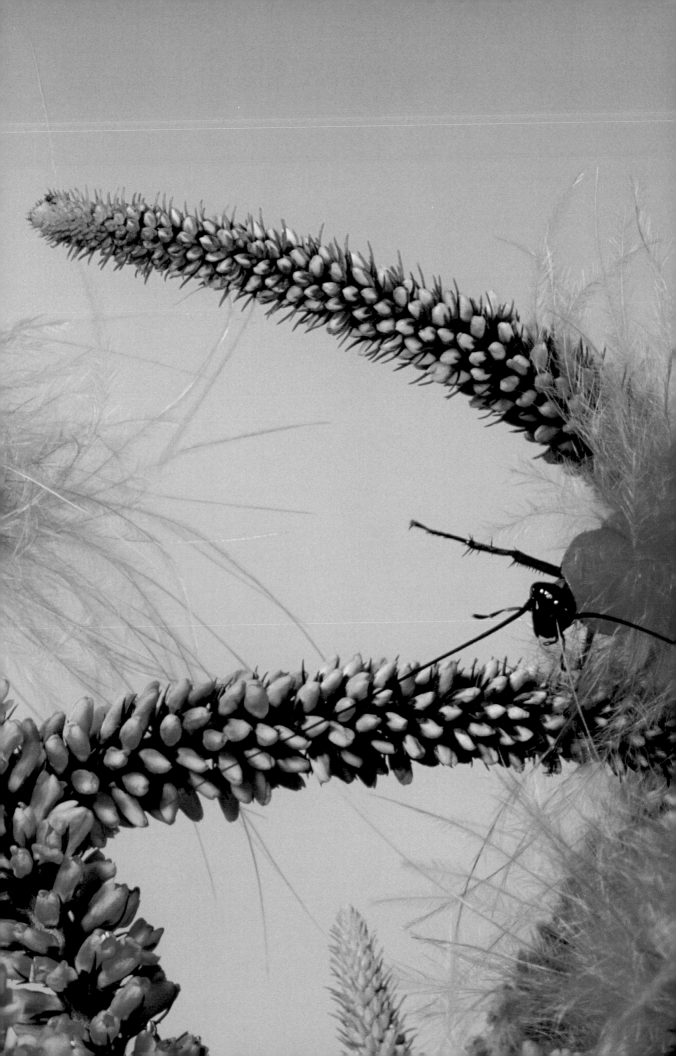

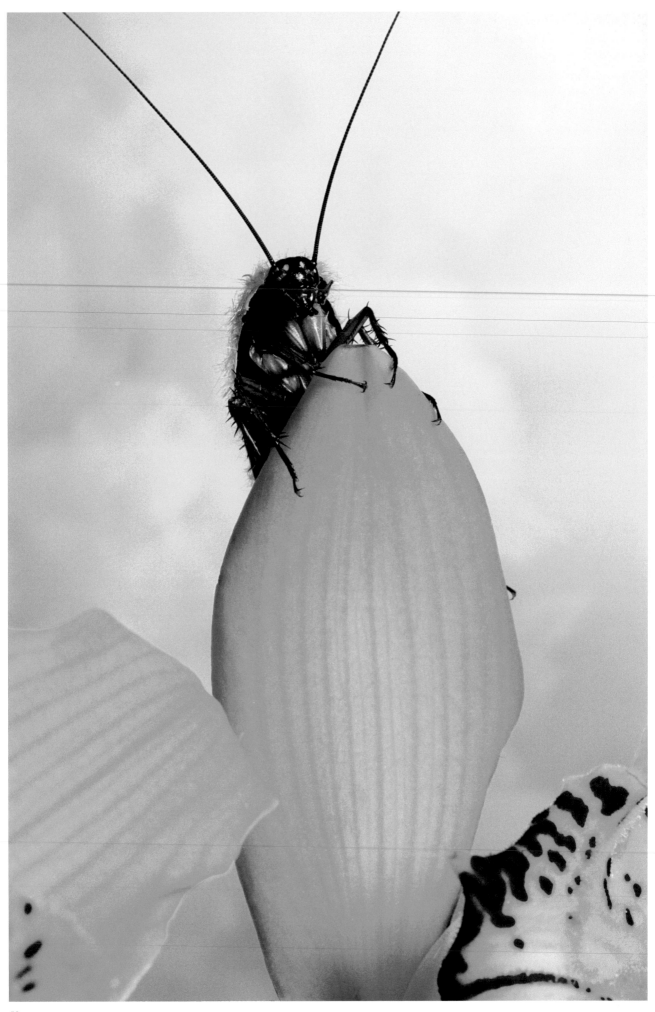

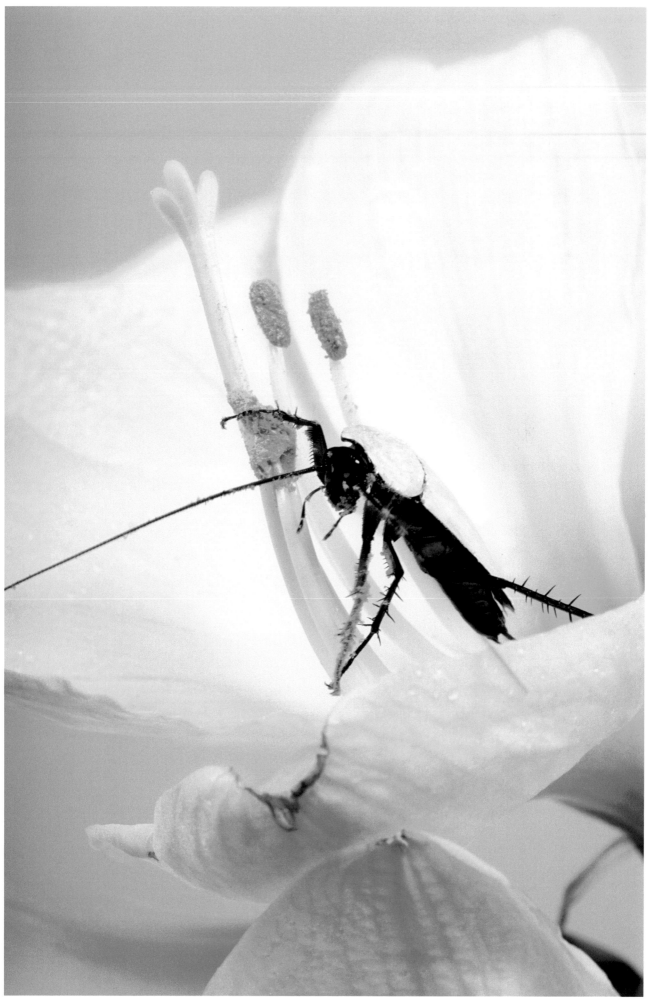

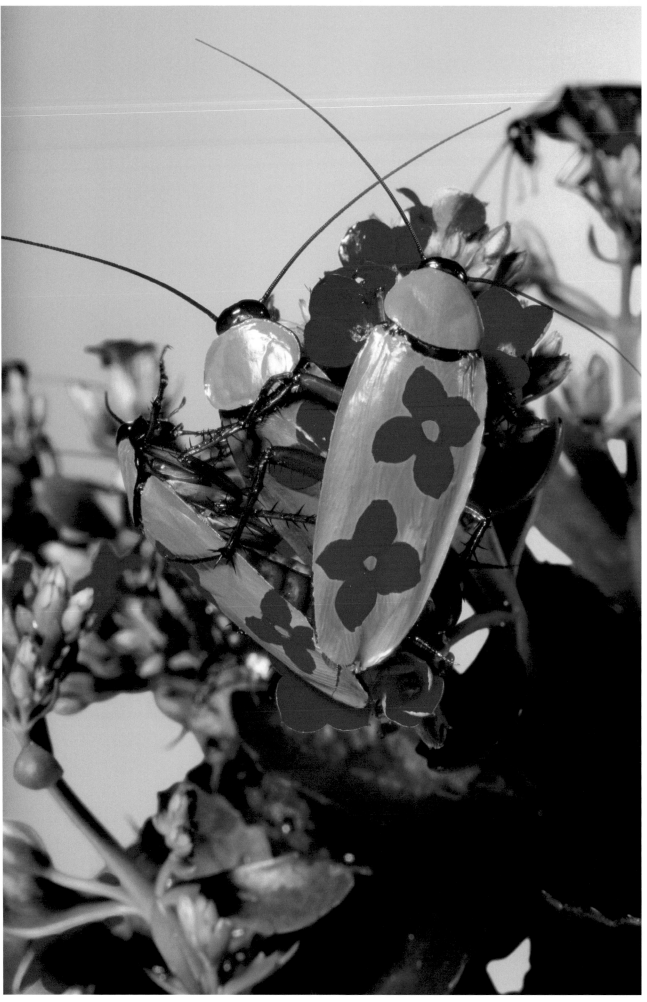

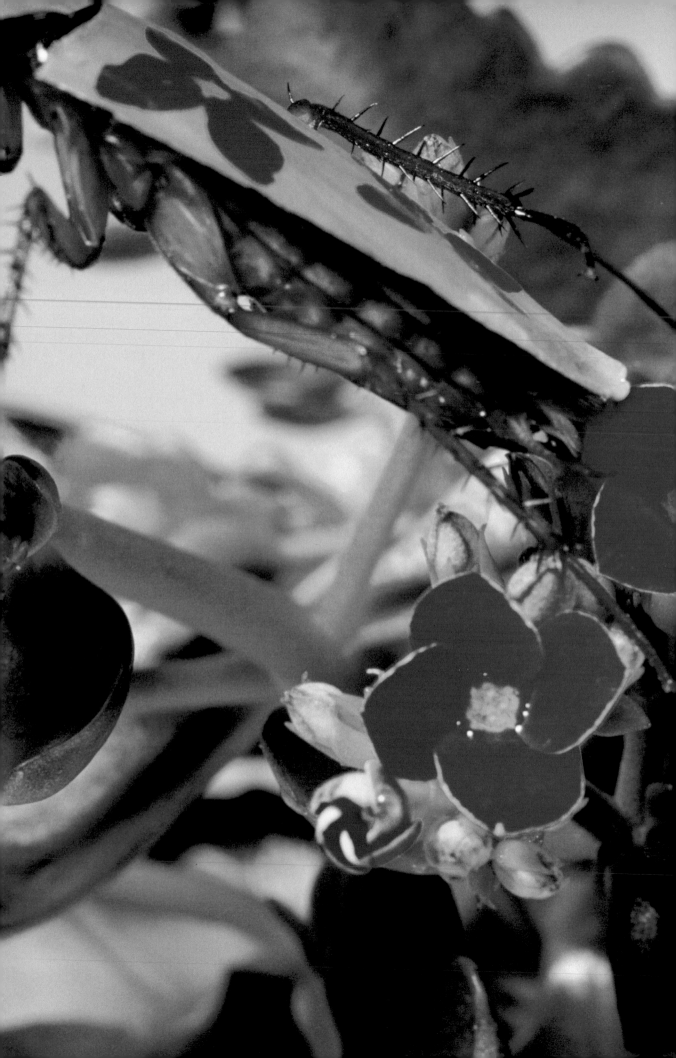

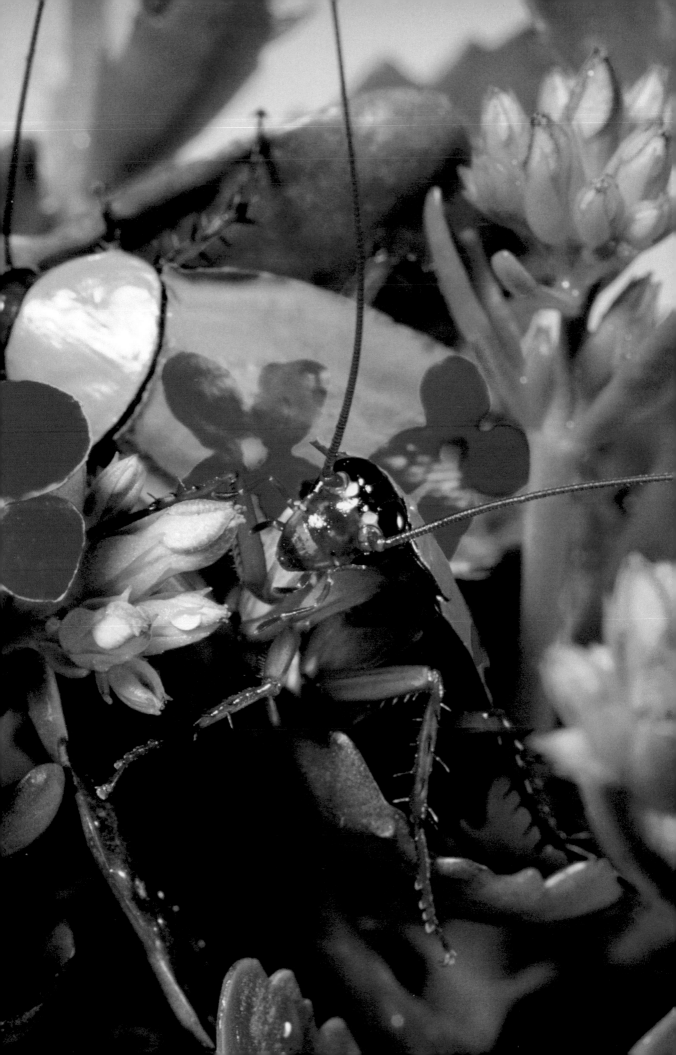

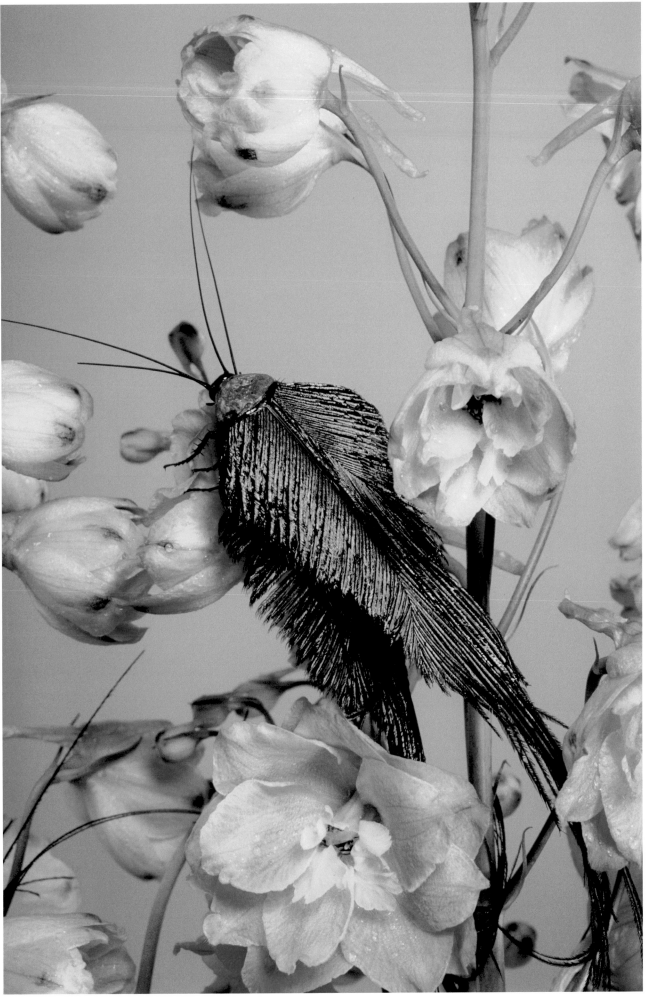

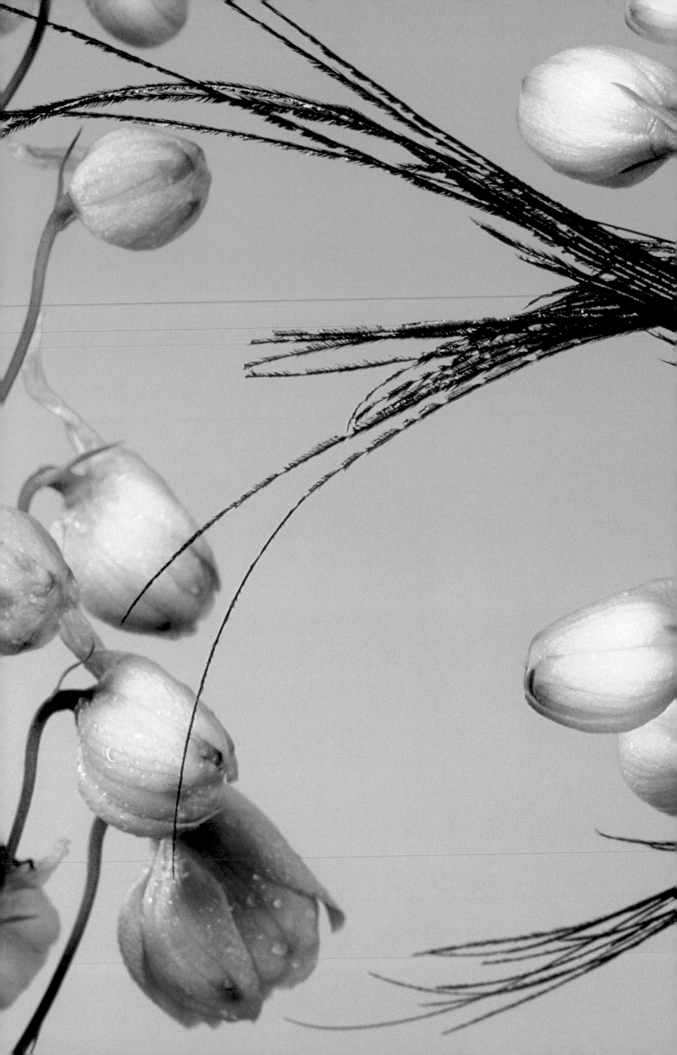

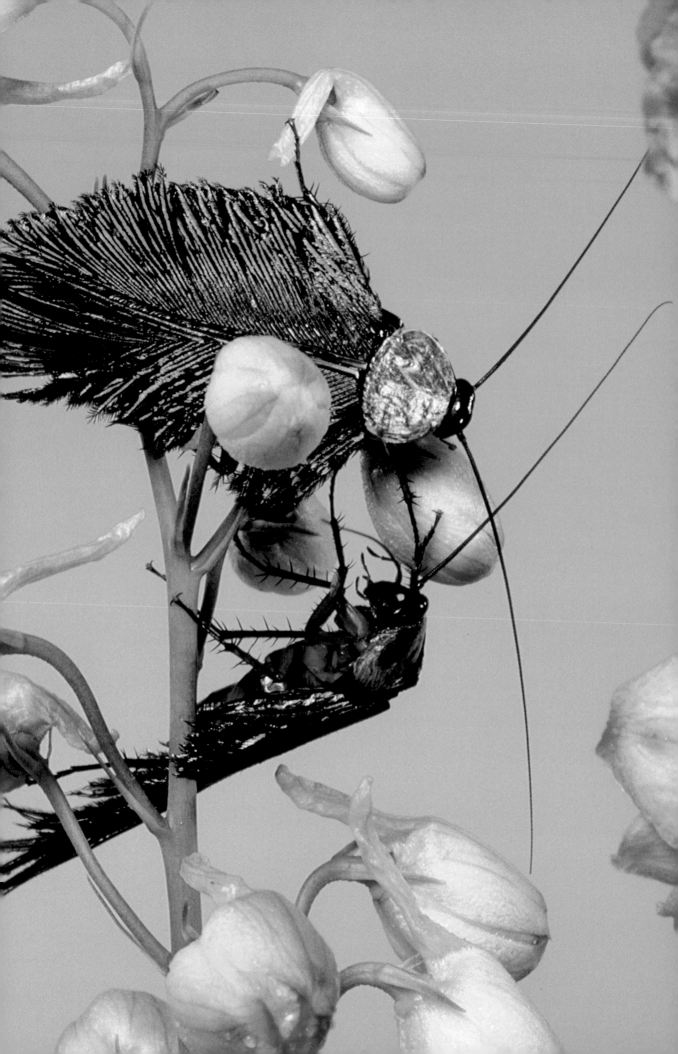

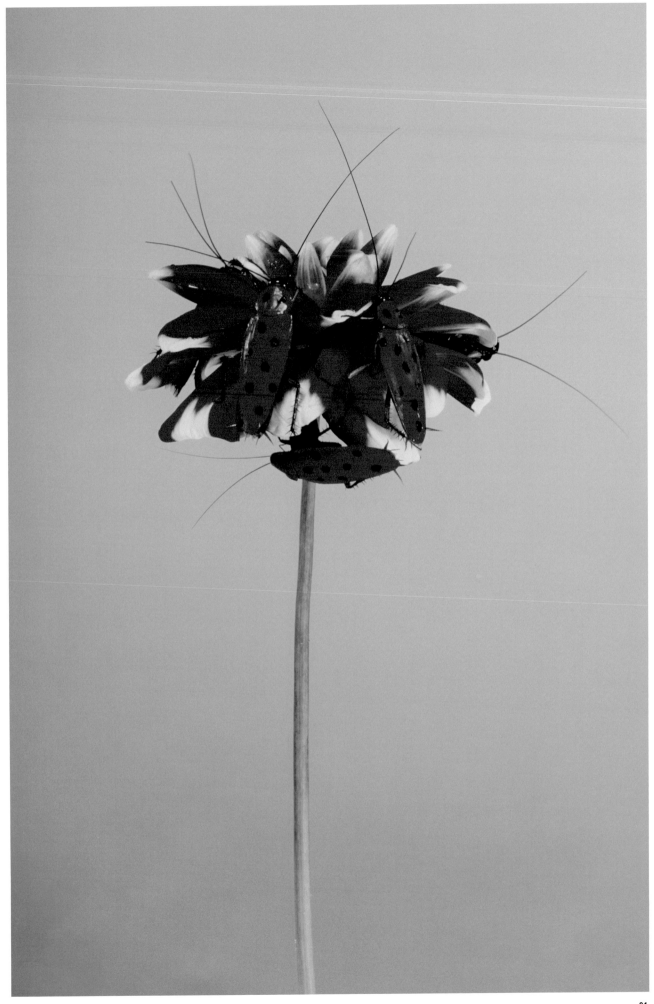

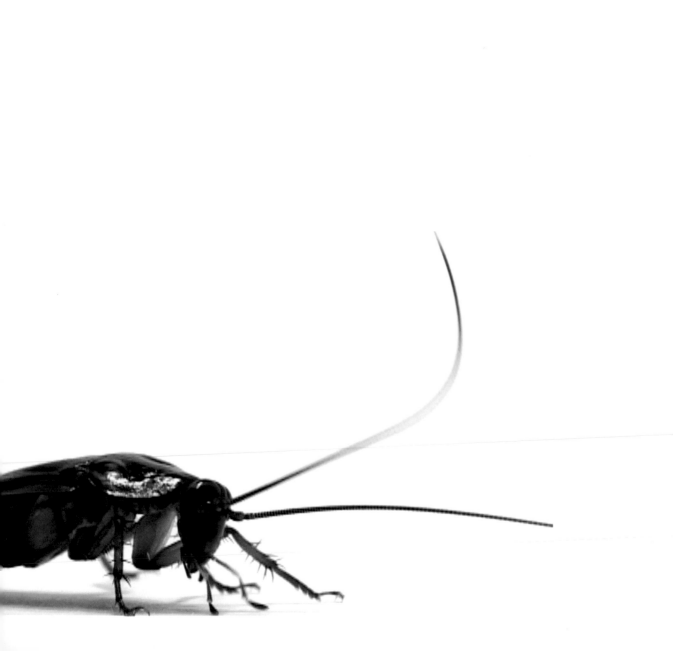

execute: *v.*
to put to death esp.
in compliance with
a legal sentence

The Lord spake. "And every creeping thing that creepeth upon the earth shall be an abomination. . . . Ye shall not make yourselves abominable with any creeping thing that creepeth, neither shall ye make yourselves unclean with them, that ye should be defiled." A creeping abomination, unclean, defiler of human spaces—this is the characterization of the cockroach for most of us in the Western world. All human societies and cultures have systems for classifying the animal world and such classifications are never neutral; they shape our emotional responses to different species and how we interact with members of them. It is not what animals are, in and of themselves, that forms and informs our thoughts and feelings about them, but rather their place within these deeply rooted classifications creates them in relation to us. They are the product of our imaginings. These social and cultural constructions, rather than scientific knowledge linked to a biological reality, shape human relations with the rest of the animal world and may determine the life or death of members of that world. Such schema define which are to be revered, which will be sacrificed to our interests, and which must be saved. Some are apparently deserving of our love and respect, some are mere things scarcely noticed, others are loathed, reviled, and hated.

The most cherished are invited, as individuals, into our homes to share their lives with us. Here begins the problem of cockroaches. They are not cherished individuals and they subvert the rules of hospitality in their trespass. Swarming en masse they intrude, uninvited, into the most intimate of our domestic spaces. They are there with us but they scuttle to avoid us and are resistant to our desire to remove them. They pollute, not by what they carry with them nor by what they do, but by their mere presence; although their presence is never mere. Our homes and our workplaces afford them shelter and nourishment, but only at the risk of death and destruction

as we wage war on them. As Marion Copeland has commented, whereas the knowledge of many other insects is pursued because of an admiration and fascination for what they are, "… cockroach study has been motivated by human hatred. Much of the study has been devoted to finding better ways of extermination—something humans seem to take special pride in doing well." Cockroaches are pestilential and the language of pest control is one of extermination, annihilation, eradication. The lives of these creatures are curtailed through suffering both the products and process of insecticide and they die in the mundane spaces of the everyday world in which they have committed their disturbing trespass.

This is not the fate, however, of the cockroaches of "Executions," which are transformed, even exquisitely transformed, in the photographs of this series. A proper insecticide death is collective and anonymous, indiscriminate, unmarked and soon swept away, but the deaths represented here are of individuals taken out of the spaces of the everyday and into the sacred space of execution. Here they are elevated through the enacted versions of highly ritualized human deaths that Chalmers has created for them. We know that these are not real deaths. Only previously dead cockroaches are executed here and have now been resurrected—posed in order to be exposed. It is perhaps in that exposure that much of the disturbing power of these images resides.

What is the viewer confronted with here? In part it is a confusion and conflation of the human and the insect. These are obviously not humans being executed, though in ordinary usage the term "execution" is reserved exclusively for humans. These are insect deaths, yet, contradictory as it may seem, the human is the spectre that animates them. Humans are executed for what others perceive as crimes and execution is the ultimate punishment, the ritual that cleanses society of its unwanted

Cockroaches are pestilential and the language of pest control is one of extermination, annihilation, eradication.

members. What then is the crime so horrendous that a cockroach should be executed for committing it? Is following its cockroach nature enough to make it a criminal who must suffer the full force of human law? In medieval Europe people thought that invading and destructive insects were sometimes deserving of legal prosecution. Perceived as malevolent and malicious creatures who were fully responsible for their aberrant behavior, they were actually tried in courts of law and confronted with their crimes before they were duly punished. Such anthropomorphism might seem irrational to us in the twenty-first century but still we do anthropomorphize. Our hatred of cockroaches is motivated by the repugnance of their transgression. Their natural behavior is culturally reconfigured as an unwanted and unacceptable attack on us. We no longer demand that they be tried, in our eyes they are clearly guilty, but we do still insist on their death as an appropriate punishment.

In a sense we are surprisingly close to the medieval case with these representations of cockroach executions. The punishment we expect for cockroaches is a mass, industrial death, so there is something intensely culturally wrong with what we are confronted in these photographs. It is wrong, not in any moral sense, but wrong in the sense of an inappropriate way of doing something—to hang, to electrocute, or to burn at the stake a cockroach. What is the point of taking the life of one individual insect in this enormously complex way? It is an ineffective way of killing a creature which is really only significant as part of an anonymous swarm. The power to execute the cockroach is a meaningless one. No other cockroaches will see this as a lesson and mend their ways. It might be ineffective as insecticide but it resonates within our deep-seated desire for vengeance.

But, again, this is not solely about cockroaches. Chalmers borrows their already dead bodies to tell another story. If these photographs cause a shiver of horror in the viewer,

Execution—perhaps appropriate (for some)
for humans but inappropriate for animals—
the very term causes us to pause, to reflect . . .

it is not merely the horror of the insect nor the immediacy of the insect death but an absent horror—a dim awareness that something is out of place in this imagery in which the present and the absent are inextricably intertwined. Execution—perhaps appropriate (for some) for humans but inappropriate for animals—the very term causes us to pause, to reflect, to think of how casual and ordinary is the normal killing of cockroaches and perhaps any other creature. These representations of executions jar for we do not normally come face-to-face with the animals killed on our behalf or for our benefit. Even confronting the death of this lowly insect is disturbing. We hate them but seeing their bodies displayed in this manner is shocking, no matter how difficult it is to empathize with the death of such an unknowable creature.

And yet these cockroaches have an immense and intense presence. Each cockroach here acquires a peculiar dignity, elegance, and individuality in its execution. Chalmers literally, by suspending it, seating it, or fixing it to a stake, elevates each creature from its creeping posture to an almost human one. What the human loses in execution these insects gain. These are deaths beyond the anonymity and massacre of insecticide. The exquisitely crafted nooses, the hand-made electric chair, the prepared stake are all created for an individual. We might not have any knowledge of them or access to them as individuals, but it as individuals they are presented to us and it is as individuals that we confront them.

As Chalmers has suggested, whether or not cockroaches have an individuality that is recognizable to humans, they are 'a charged subject' that offers 'a blank canvas' to the receptive and reflexive viewer. Onto the canvases of their bodies the artist has inscribed a disturbing imagery of intertwined human and insect lives … and deaths.

—GARRY MARVIN

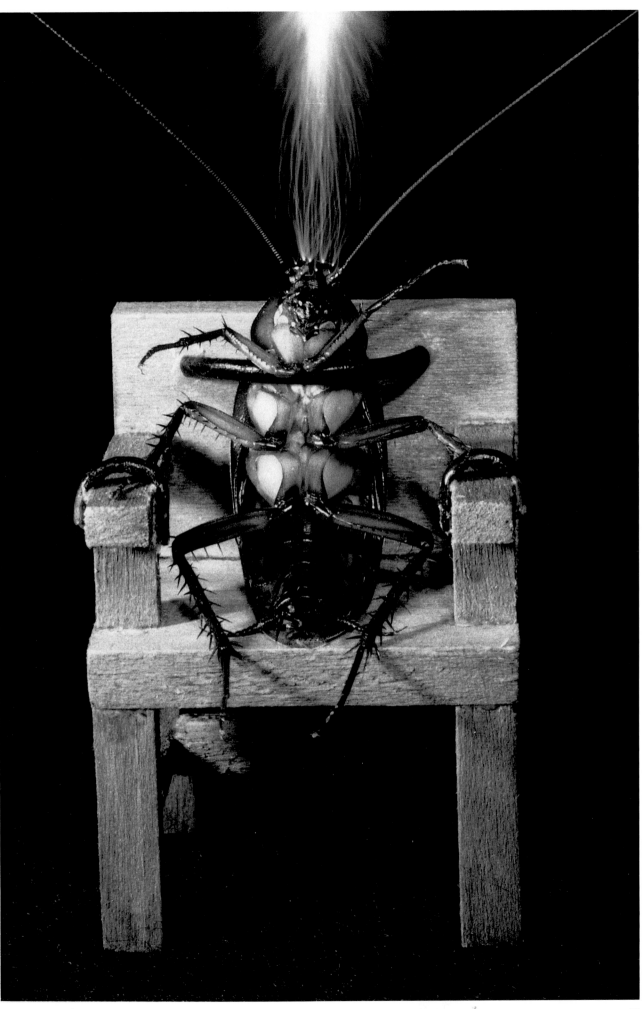

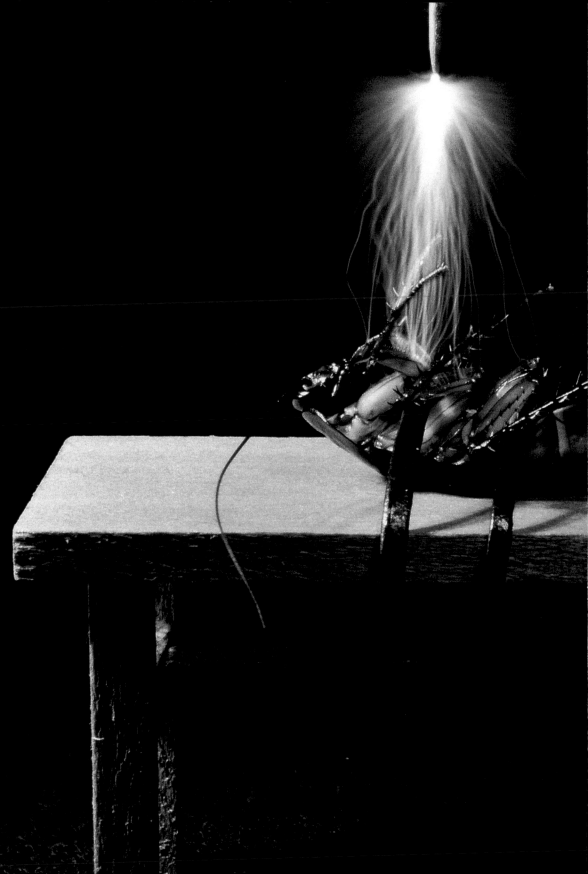

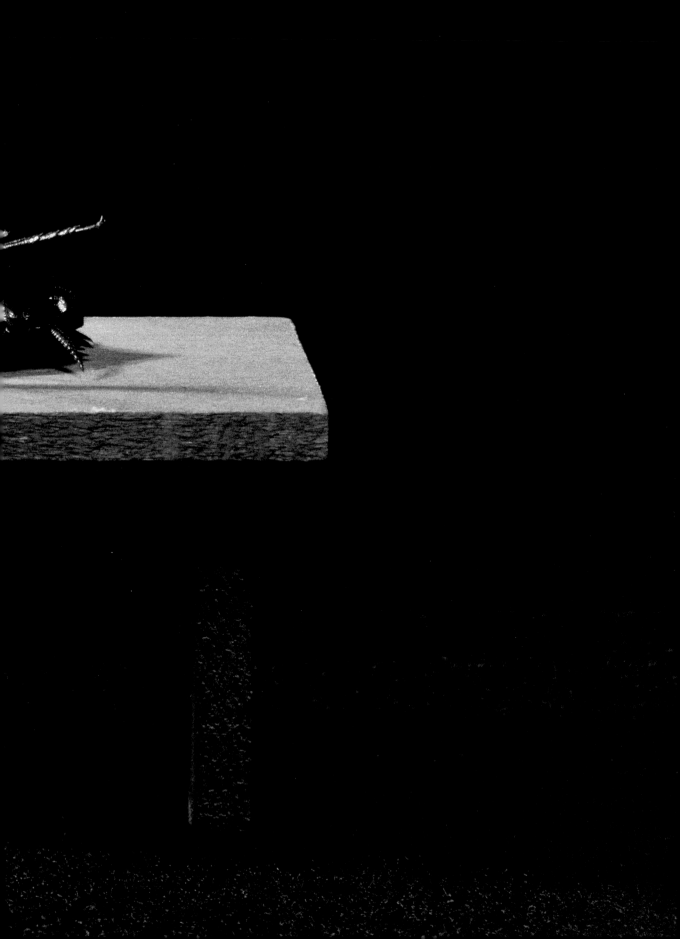

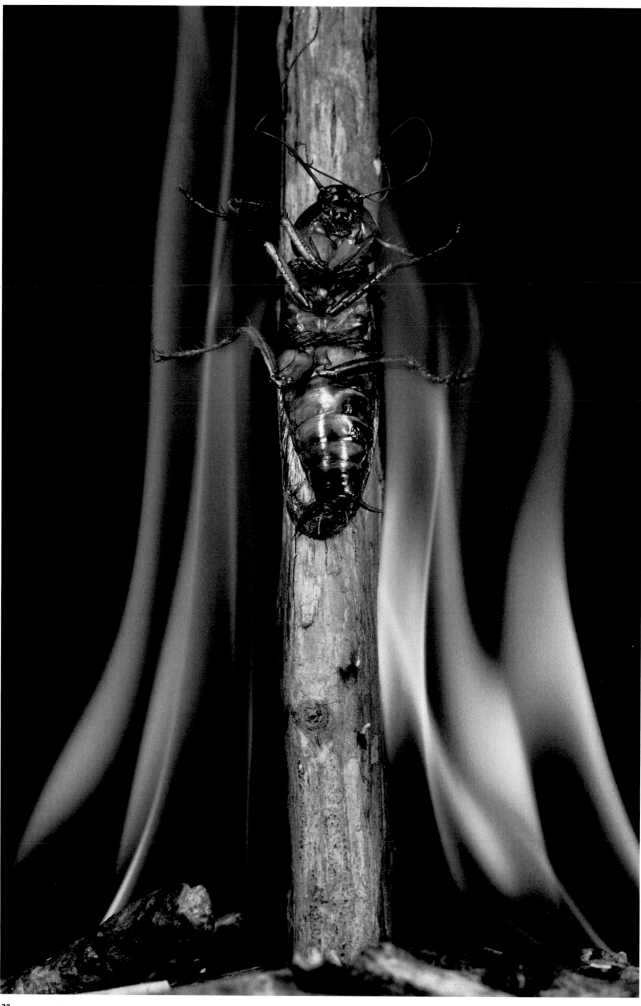

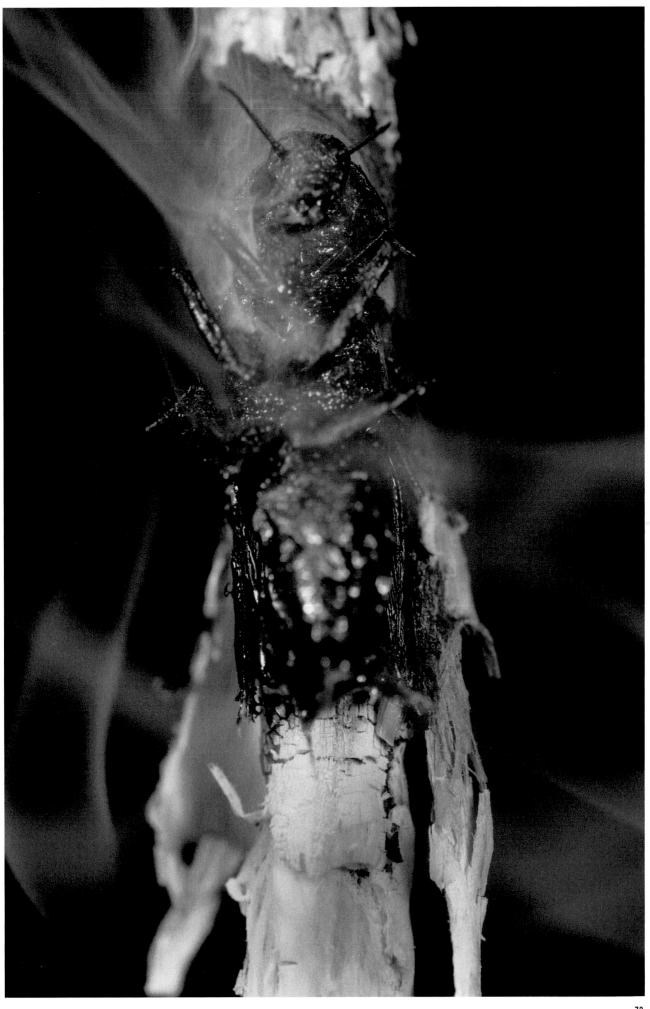

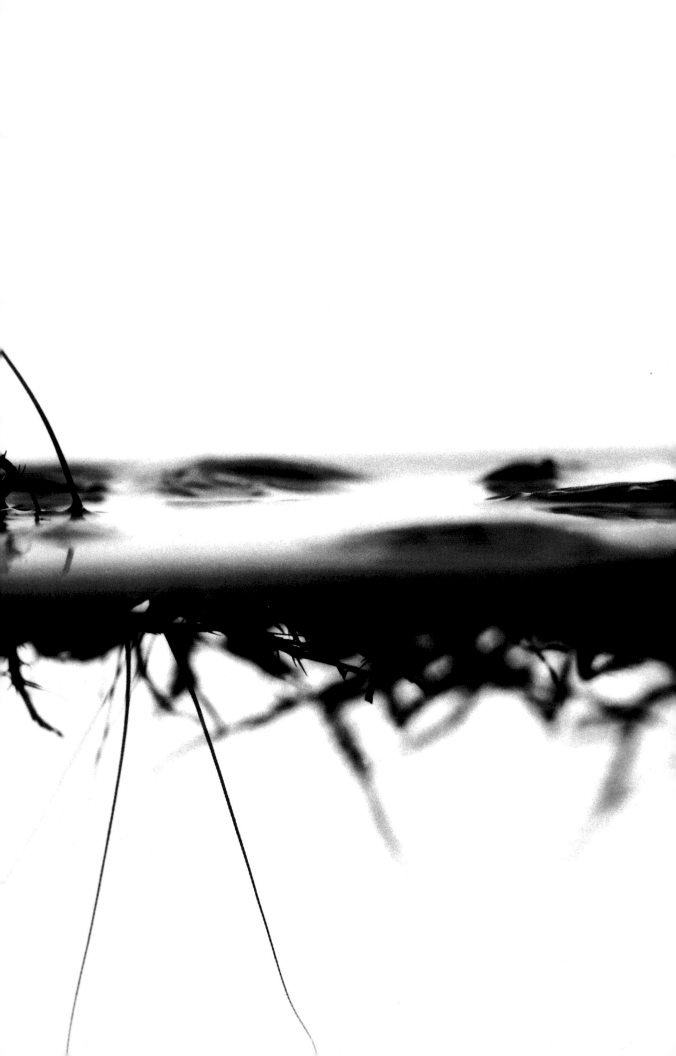

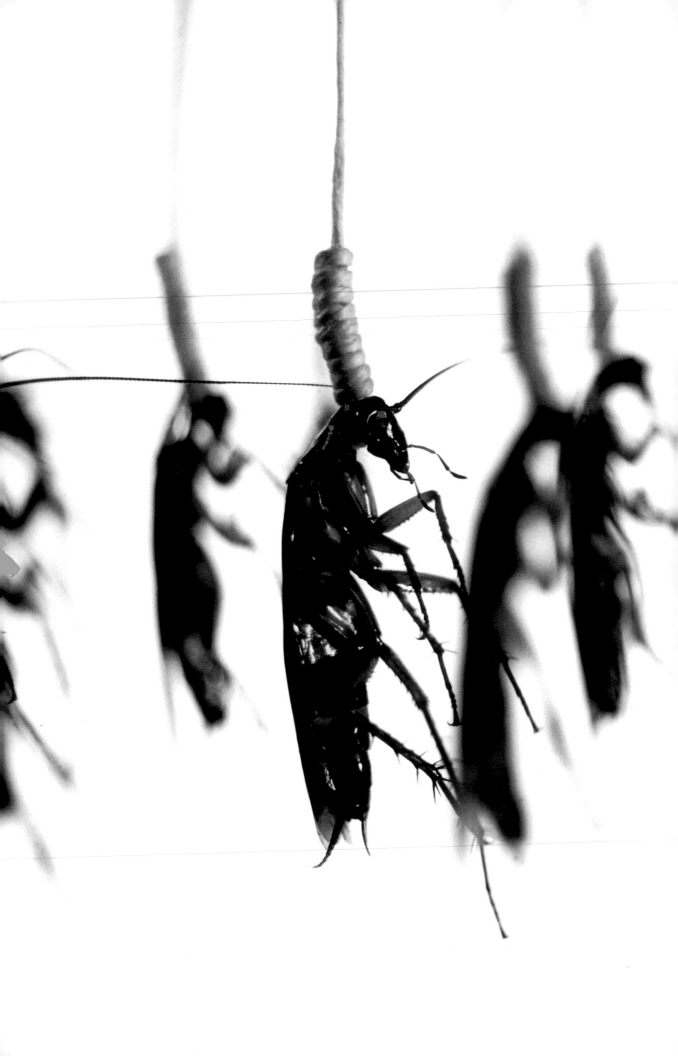

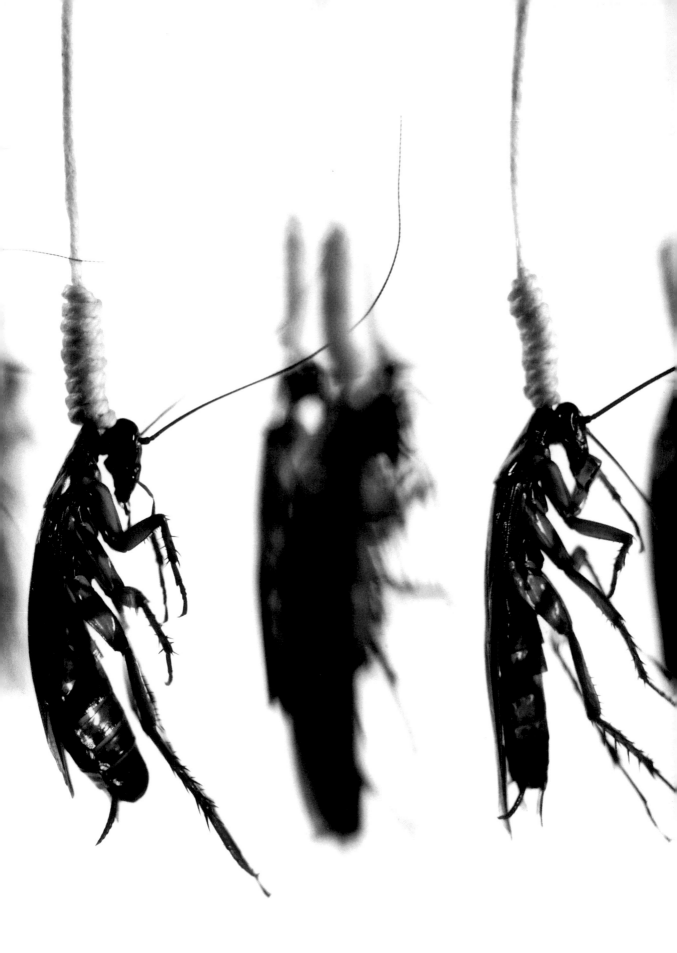

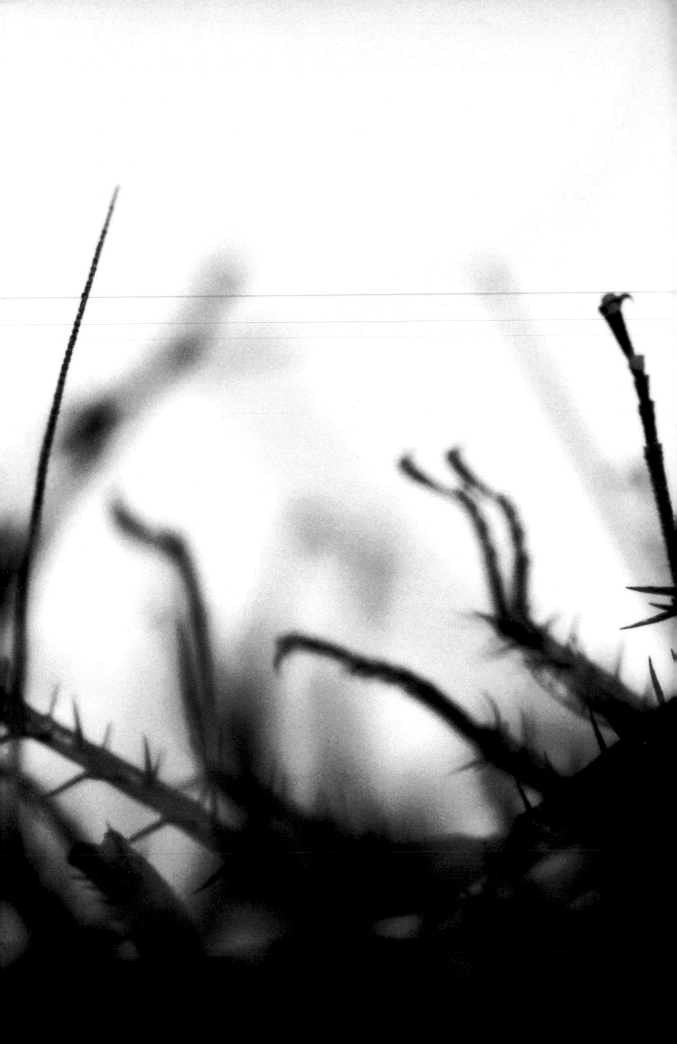

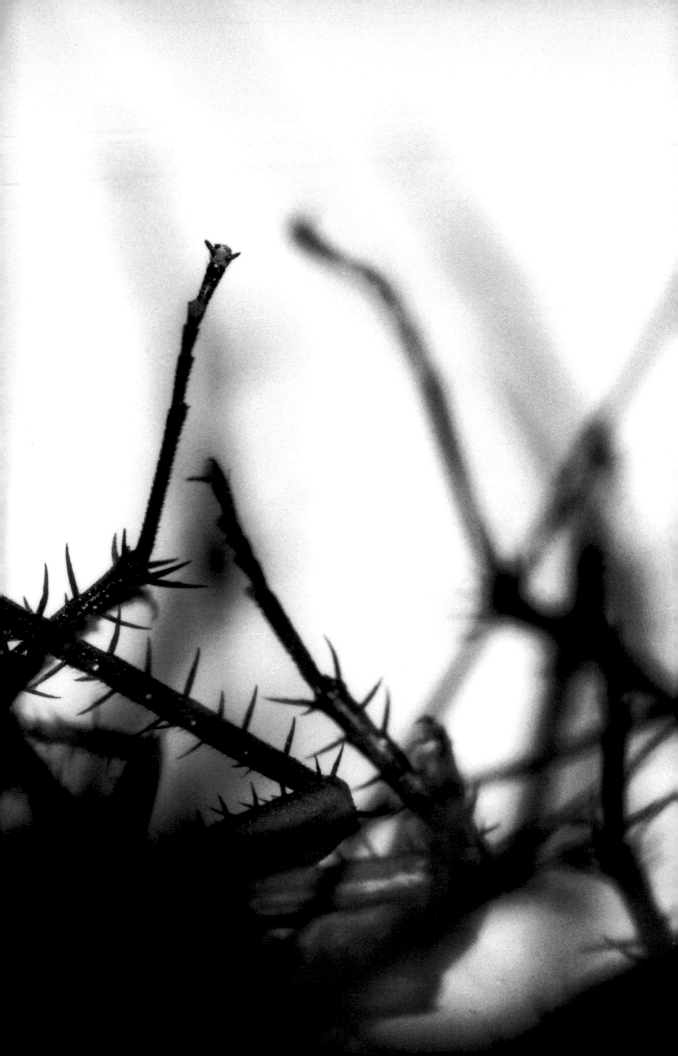

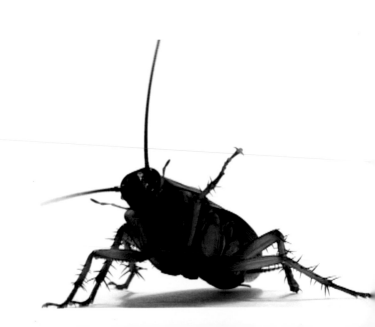

artist: *n.*
one skilled or versed
in learned arts;
one who professes
and practices
an imaginative art

CATHERINE CHALMERS: EXCERPTS

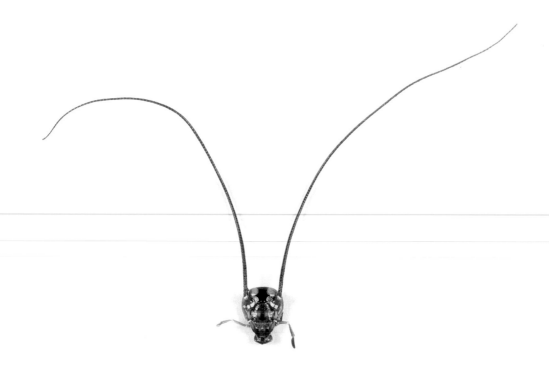

Excerpts from a conversation, June 2004.

Insects are a window into the unimaginable. Their biology and behaviors are routinely bizarre and enigmatic to us—they are refreshingly outside the human perspective. I think that our experience can be enhanced by an attempt to understand and give meaning to other life forms. Yet, is it possible that a human-centric viewpoint is setting the stage for an impoverished environment?

• • •

Where nature and culture collide is a nexus of fear and confusion. With my previous book, *Food Chain*, I wanted to explore a basic process of the natural world—killing and eating, being eaten alive—away from which we have endeavored to civilize ourselves. The carnage in *Food Chain* was deeply disturbing to many viewers. Although I spent much of my time on the project providing meticulous care for the animals I worked with, many viewers blamed me when they saw, for example, images of a snake eating a baby mouse—as if I had killed the mouse. I was fascinated by the strange disconnect between what people seem to want to believe happens in nature

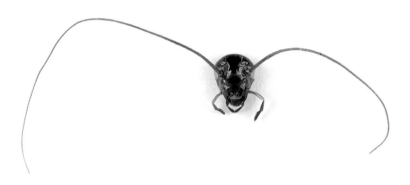

and what actually does happen. The snake, of course, needs to eat, regardless of our opinions.

• • •

With *American Cockroach*, I am interested not so much in troublesome behavior as in an animal humans find problematic. The roach, and the disgust we feel for it, make for a rich conduit to the psychological landscape that inculcates our complex and often violent relationship with the animal world. I can think of few species that are as thoroughly loathed as the cockroach. But interestingly enough, although they carry this heavy burden of our hostility, they don't do very much in terms of behavior. They don't eat in a dramatic way, and they certainly don't have the wild sex life of, say, the praying mantis. They don't sting, bite, or carry the dangerous pathogens that flies, mice, and mosquitoes regularly do. Having a cockroach in your kitchen is not like having a venomous snake living in the house. There's nothing about the animal that is life-threatening. The dichotomy of the roach being a loaded subject, yet in habit, a fairly blank canvas, allowed me to bring more to this work.

Trophy, 2003 (2 of a series of 5);
cockroach head on paper; 14 x 11 inches

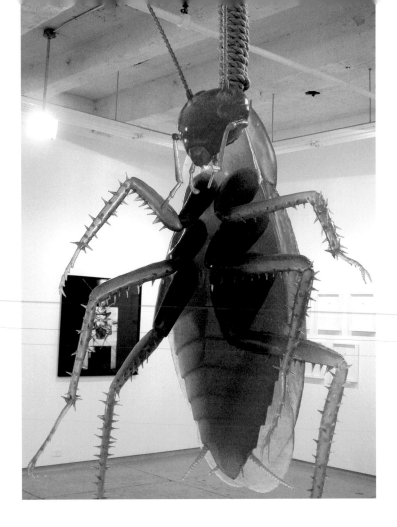

It's likely that there are a multitude of factors that fuel our feelings about cockroaches. They're nocturnal, coming out at night when we are asleep and vulnerable. They also operate in numbers, whereas we see ourselves as individuals. If we find ten in the kitchen, we know there are hundreds more behind the walls that we can neither see nor get at—a hidden enemy is horrifying to us. And by mutating quickly they can genetically outwit the technologies we throw at them. I also wonder if we have an atavistic memory of when mammals were a diminutive species ruled by the dinosaur. Are we skittish about being dominated again? Who knows? Cockroaches outnumber us, we can't control them, and they don't share our values.

● ● ●

It has never been my intention, though, to offer them an apology, to say we shouldn't hate or shouldn't kill them. I'm not advocating for their conservation or their destruction. What interests me is that the degree to which people hate cockroaches is so disproportionate to the actual potential for threat in the actions of the animal. This schism is indicative of the subjectivity—perhaps arbitrariness—with which we respond to nature in general. The cockroach is like a distorting mirror that amplifies the attitudes we harbor.

● ● ●

Hanging, 2003; resin, rubber, rope; 6 feet
Pile of Legs, 2003; resin; 6 feet diameter

One of the things I discovered when reading up on the American cockroach is that they are no longer found in the wild. They have existed for hundreds of millions of years, have survived several mass extinctions, yet we have succeeded in changing how they live. Our homes are now their natural habitat. They are, in a sense, our alter-egos, the shadows that clandestinely follow in our wake. As humans dispersed from Africa, where roaches too are believed to have come from (Linneaus misnamed them *Periplaneta americana*), they have accompanied us through our colonization of the planet.

I have a theory that early Homo sapiens living in caves probably did not find the cockroach as abominable as we do now; certainly they had more dangerous animals to fear. Our hatred of the roach has perhaps grown in proportion to the boundaries we have erected between ourselves and the natural world. These animals are one of the few remaining species that can cross over at will and challenge those barriers. I think, at a fundamental level, their trespass upsets our confidence in our ability to successfully control and transform nature to suit our needs and desires.

• • •

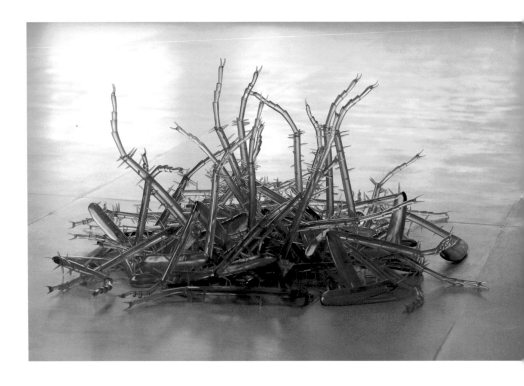

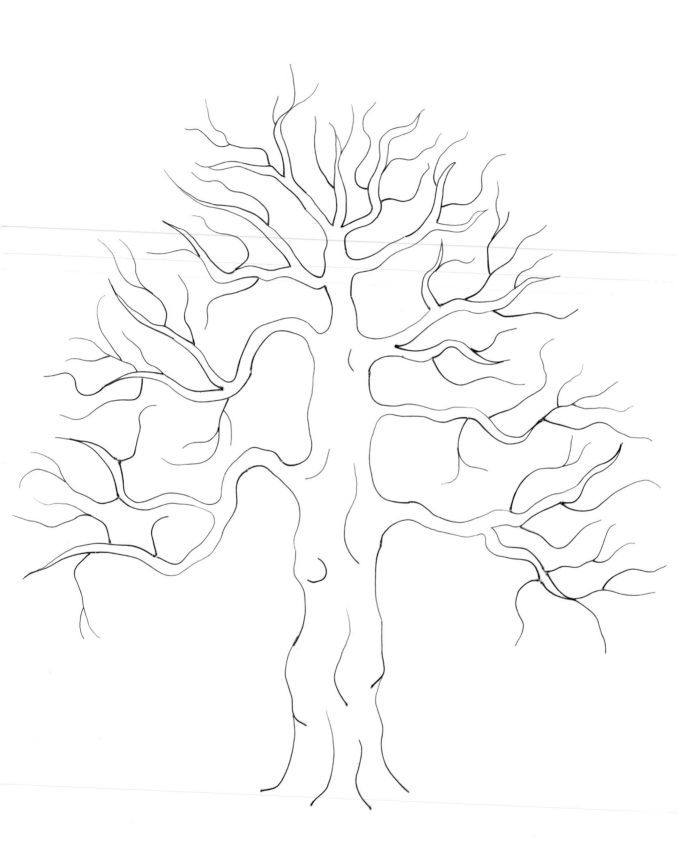

The distance humans have forged between ourselves and nature is creating villains out of species that were originally seen as benign, and increasingly transmogrifies animals into one of two categories: pets or pests. And, of course, the animals that fall outside these sets are rapidly becoming extinct. Our expanding lifestyle decreases the number of animals on which we spend millions to save, and conversely gives rise to the so-called "weed species," the animals on which we spend millions to exterminate. It's a portentous conundrum. People persevere in feeding their need for contact with nature, but what satisfies that longing is increasingly notional. Our culture surrounds itself with natural forms; patterns of flora and fauna abound on walls, sheets, and clothes, but we remove ourselves from the real things in their normal environments. I think we have become a species that prefers the substitute.

• • •

What are the aesthetics of human empathy toward animals? What if cockroaches were red with black spots like a ladybug, or green like a plant, or iridescent like a dragonfly? Or perhaps came in a variety of colors and patterns, like cats? People seem to prefer soft and fuzzy to hard and shiny, big eyes to thin antennae, feathers to scales, colorful creatures to dull ones. These are choices based on abstract visual qualities, often independent of the animal's behavior. And I think these preferences have had a formative role in determining our attitudes toward specific species, and even entire classes of creatures. They have played a part in defining what we find to be "good nature" as opposed to "bad nature." Unfortunately for the roach, it embodies several of our least-favored aesthetic attributes.

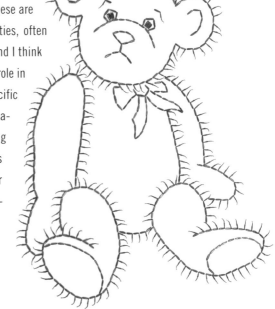

Tree, 2003; cockroach antennae on paper; 14 x 11 inches
Teddy Bear, 2003; cockroach legs on paper; 14 x 11 inches

I found that once I got past the dark, twitchy exterior, the roach is remarkably subtle and beautiful. Its wings are a glowing, translucent amber, its lithe legs are accented with randomly-drawn spikes, and its antennae explore the world with the grace of a ballerina's arms. I was surprised to be allured by its shape—its body parts are formally compelling, and this is what led me to expand this project into drawing and sculpture. From there, the roach's syncopated, rhythmic gait led me to video.

• • •

People prefer to see insects in a garden, pollinating flowers and being useful. That's idealized nature. But of course, most insects are predators, savagely ripping apart fellow insects, or, in the case of the cockroach, acting as scavengers, recycling waste and debris. Humans don't like scavengers. And that the American cockroach can successfully scavenge off of us is the worst of insults. We have worked tirelessly to coerce nature to match our vision, but would the world really be a better place if all insects were pretty and only did nice things?

• • •

I sometimes paint or add spines or feathers to the shells of my roaches. These embellishments are superficial and fall off in a few days, leaving the roach unharmed. But the act of transforming the animal brings up an interesting characteristic of human behavior. We specifically set out to shape the planet as if it is a tabula rasa for our desires. The terror of whatever a roach does to us pales in comparison to what we can do to it. Genetic engineering is opening up new possibilities for designer plants and animals. Pretty soon, "glowfish" will be available—goldfish engineered to fluoresce, created just for our entertainment. If roaches are here to stay, might we take an alternate route and begin pest manipulation instead of pest extermination? Engineer them to look like a favorite insect, or

Stills from *Crawl Space*, 2004; video, 10 min. 19 sec.

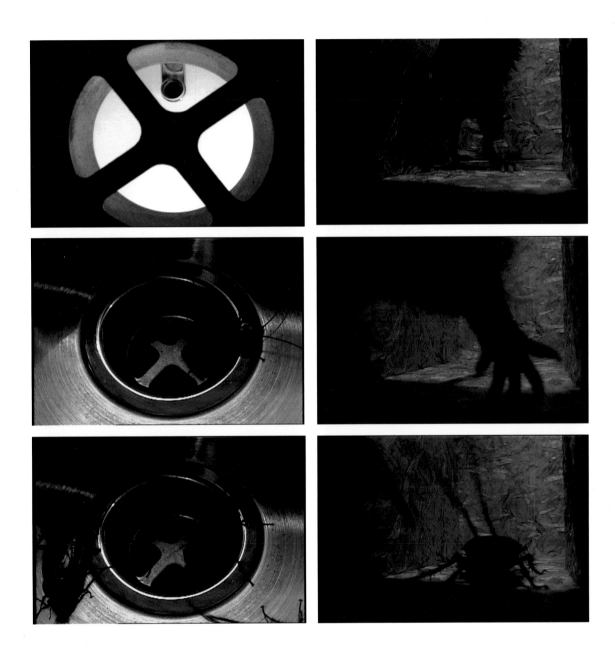

mammal, or perhaps the kitchen wallpaper? There is real power and bite behind our aesthetic choices. We have been practicing this craft for millennia, such as carving a wolf into a toy poodle, but now we have more tools in our box.

• • •

Death ties us to the roach in a unique way. We kill them—they survive. We kill ourselves—they survive. I wanted this body of work, though, to get away from the discussion of specific deaths. So my executions were reenacted with already-dead bugs. I have been raising roaches for years and consequently collecting the dead for years; their corpses animate this part of the project. The "Execution" series is not about the suffering humans have endured at the hands of humans, but what other species have endured at the hands of humans. I do not want, in any way, to

Bumble Beetle, 2004; pencil and fuzz on paper; 23 x 29 inches
Pop Beetle, 2004; pencil and colored pencil on paper; 23 x 29 inches

diminish the pain and horror that we have experienced through the centuries with these methods of killing. It is the opposite perspective: not looking in but looking out across the animal barrier that I am endeavoring to explore through this work.

• • •

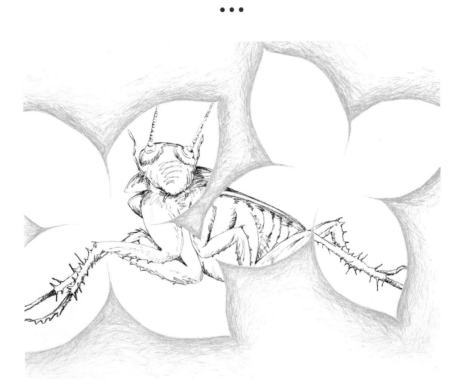

We have difficulty looking something in the eye as it dies—even if we really want it dead. Not so other predators. For example, the dog; the more its squeaky toy squeals, mimicking a suffering prey, the more excited the dog gets. Humans are incredibly efficient killers, yet remarkably queasy at facing or acknowledging what we do. For us, there is a disjuncture between mass, anonymous, silent deaths, and those that have been individualized. We do not feel the same emotion and responsibility for what we do not witness, whether it is a behind-the-wall pesticide

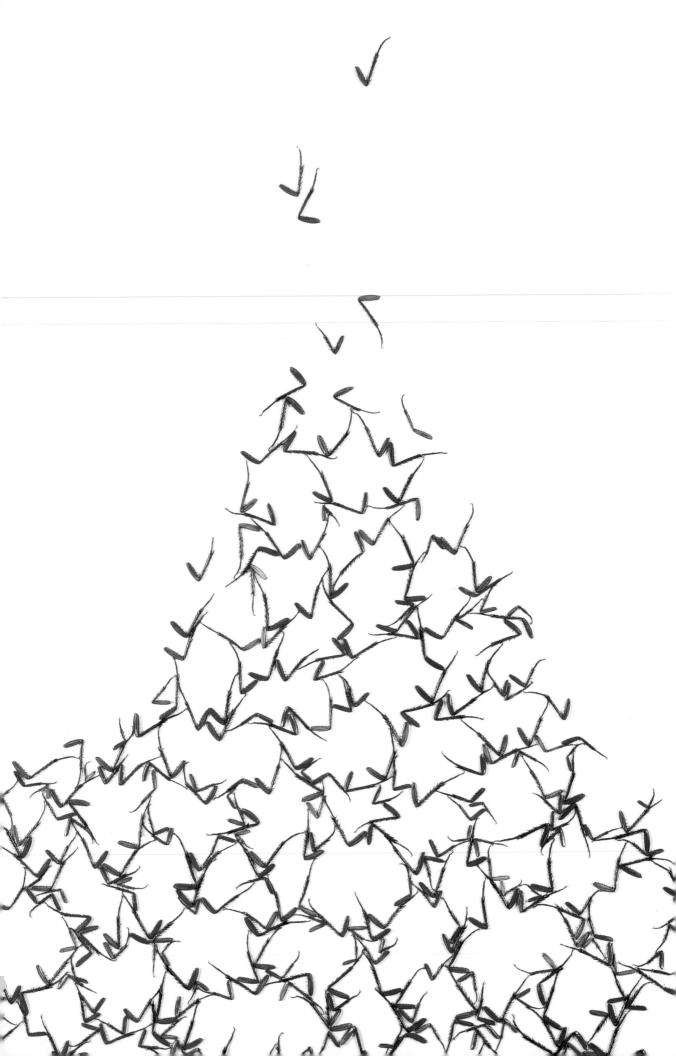

death, or the graver problem of wildlife loss from habitat destruction. But, for the animal facing extermination or extinction, what meaning are our distinctions?

• • •

We are at a time in history when we are becoming aware of the larger impact we have on other species. The roach, strangely enough, is emblematic of the questions we face as we struggle to decipher our relationship to the animal world in general. What do we love, what do we kill, what do we save, and what becomes extinct? We have been drawing lines in the sand forever, but maybe now is a good time to re-imagine what's on the other side.

Pit (Legs), 2003 (detail); cockroach legs on paper; 30 x 11 inches
Eyeglasses, 2003; cockroach antennae on paper; 11 x 14 inches

CATHERINE CHALMERS holds a B.S. in Engineering from Stanford University and an M.F.A. in Painting from the Royal College of Art, London. She has exhibited around the world, at P.S. 1 (a MoMA affiliate), New York; Mass MOCA, North Adams; Corcoran Gallery of Art, Washington, DC; Yerba Buena Center for the Arts, San Francisco; Museum of Contemporary Photography, Chicago; Kunsthalle Basel; Kunsthalle Vienna; and MOCA Taipei, among others. Her work has appeared in a variety of publications, including the *New York Times*, *ArtNews*, *Artforum*, *Flash Art*, *Blind Spot*, the *Sunday Telegraph*, the *Independent on Sunday*, *Harper's*, and *Discover*, and has been featured on PBS, CNN, NPR, and BBC. Chalmers lives and works in New York City.

STEVE BAKER is Reader in Contemporary Visual Culture at the University of Central Lancashire, U.K, and author of *The Postmodern Animal* and *Picturing the Beast: Animals, Identity, and Representation*. He is a member of the Board of Editors of *Society and Animals*, and guest-edited a special issue of that journal on "The Representation of Animals." He is currently researching artists' engagement with contemporary ethical issues, and he has lectured on his research at the New Museum of Contemporary Art, New York, the Musée d'art contemporain de Montréal, and the Natural History Museum in London. He has contributed to books and catalogues on the work of individual artists, such as *The Eighth Day: The Transgenic Art of Eduardo Kac*; *Lyne Lapointe: La Tache Aveugle*; and *Olly & Suzi: Arctic, Desert, Ocean, Jungle*, as well as to group exhibition catalogues such as *The Human Zoo* and recent edited collections including *Representing Animals* and *Zoontologies: The Question of the Animal*.

GARRY MARVIN is Reader in Social Anthropology at the University of Surrey Roehampton, UK. He specializes in studies of human/animal relationships and his research has led to publications on bullfighting and cockfighting, on zoos and English foxhunting. He has a particular interest in the social and cultural constructions of the killing of animals by humans. His present research centers on hunting and human/wolf relationships.

LYALL WATSON was born in southern Africa in 1939. He apprenticed in paleontology under Raymond Dart, the discoverer of *Australopithecus*, the first African hominid, an experience that led to anthropological studies in Germany and Holland. Watson subsequently earned a Doctor of Philosophy degree in ethology under the supervision of Desmond Morris of the London Zoo. While involved in archaeological fieldwork in Jordan in 1967, Watson was invited to direct the rebuilding of a major zoo in Johannesburg. He has also worked as a presenter and producer of documentary programs for BBC Television in London, and in 1970, formed Biologic of London, a science consultancy that designed zoos and organized expeditions. He is the author of over twenty-three books, including the 1973 best seller, *Supernature*.

I would like to acknowledge my appreciation, gratitude and respect to the following people who have been instrumental in the creation of *American Cockroach*. Thank you for your support and generosity.

Michelle Dunn Marsh

Ellen Harris, Lesley Martin, and the Aperture Foundation

Liron Unreich

April Calahan-McDonald, Nathan Shay, Margaret Hall Silva at Grand Arts

Philip Isles and the Robert Lehman Foundation

Lyall Watson

Steve Baker

Garry Marvin

Tan Lin

Betty Faber

Alberto Caputo

Michael Webber

Sean Kelley

Henrique Faria

Tom Gitterman

Sue Young

Ed George

Brian Hogan

Dale and Doug Anderson

Susan and Chip Kessler

Karen Atta, Mijo Manchevski and Atta

Jason Liu, Sean Barry, Raja Sethuraman and Color Edge

Sergio Purtell and Black and White on White

Erick Zanazanian and Erizan Mounting

Joe Rodriquez, JR Mounting

Jonah Frameworks

Reid Tratenberg, Hope Frames

Reinhard Spieler, Museum Franz Gertsch

Stefan Wimmer and galerie im park

Alexis Hubshman, Peter Surace, and Rare

Bridget Ashley-Miller and Paul Percy, PercyMiller Gallery

Leisa and David Austin and Imago Galleries

David Berman and dberman gallery

Barbi Reed and Anne Reed Gallery

Liz and Jim Chalmers

and my husband, Charles Lindsay

Flowers, 2004 (detail); cockroach antennae and wings on paper; 11 x 14 inches

Editor: Lesley A. Martin
Designer: Michelle Dunn Marsh
Production: Bryonie Wise

Printed and bound in China

The staff for this book at Aperture Foundation includes:
Ellen S. Harris, *Executive Director;*
Roy Eddey, *Director of Finance and Administration;*
Lesley Martin, *Executive Editor, Books;*
Lisa A. Farmer, *Production Director;*
Andrea Smith, *Director of Publicity;*
Linda Stormes, *Director of Sales & Marketing;*
Diana Edkins, *Director of Special Projects;*
Work scholars: Lea Golis, Julie Schumacher

Aperture Foundation, a not-for-profit organization, publishes *Aperture* magazine, books, and limited-edition prints of fine photography and presents photographic exhibitions worldwide. A complete catalog is available on request.

Aperture Foundation,
including Book Center and Burden Gallery:
20 East 23rd Street, New York, New York 10010.
Phone: (212) 505-5555, ext. 300.
Fax: (212) 979-7759.
E-mail: info@aperture.org

To subscribe to *Aperture* magazine write Aperture, P.O. Box 3000, Denville, New Jersey 07834, or call toll-free: (866) 457-4603. One year: $40.00. Two years: $66.00. International subscriptions: (973) 627-2427. Add $20.00 per year.

Distributed outside North America by
Thames & Hudson Distributors Ltd
44 Clockhouse Rd , Farnborough
Hampshire
GU14 7QZ
United Kingdom
Tel +44 (0) 1252 541602
Fax +44 (0) 1252 377380
Web www.thamesandhudson.co.uk

FIRST EDITION
10 9 8 7 6 5 4 3 2 1

Feathers, 2004; cockroach antennae
on paper; 14 x 11 inches